THE WEAR &
DERWENT RAILWAY

ROB LANGHAM

AMBERLEY

First published 2022

Amberley Publishing
The Hill, Stroud,
Gloucestershire, GL5 4EP

www.amberley-books.com

ISBN: 978 1 3981 0652 9 (print)
ISBN: 978 1 3981 0653 6 (ebook)

British Library Cataloguing in Publication Data.
A catalogue record for this book is available from the British Library.

Typeset in 10pt on 13pt Celeste.
Typesetting by SJmagic DESIGN SERVICES, India.
Printed in the UK.

Contents

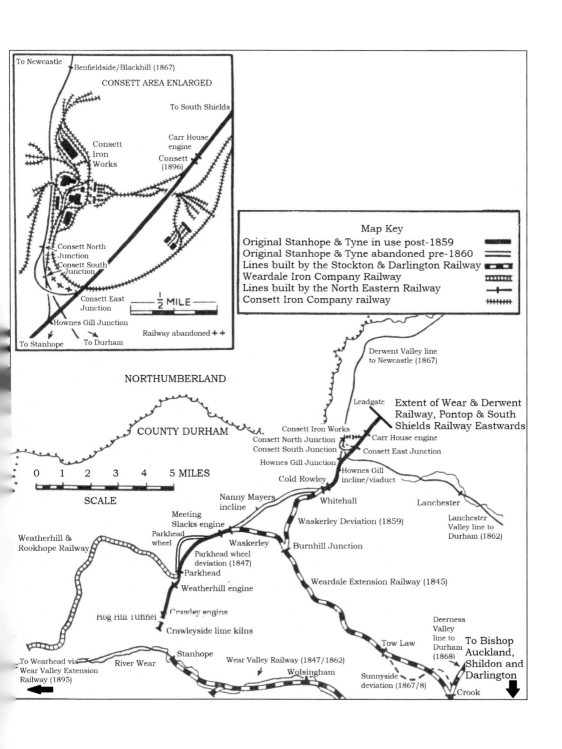

To Newcastle

Benfieldside/Blackhill (1867)

CONSETT AREA ENLARGED

To South Shields

Carr House
engine

Consett
Iron
Works

Consett
(1896)

Consett North
Junction

Consett South
Junction

Consett East
Junction

½ MILE

Hownes Gill Junction

To Stanhope To Durham Railway abandoned ++

Map Key
Original Stanhope & Tyne in use post-1859
Original Stanhope & Tyne abandoned pre-1860
Lines built by the Stockton & Darlington Railway
Weardale Iron Company Railway
Lines built by the North Eastern Railway
Consett Iron Company railway

Derwent Valley line
to Newcastle (1867)

NORTHUMBERLAND

Leadgate Extent of Wear & Derwent
Railway, Pontop & South
Shields Railway Eastwards

COUNTY DURHAM

Consett Iron Works
Consett North Junction Carr House engine
Consett South Junction Consett East Junction
Hownes Gill Junction
Cold Rowley Hownes Gill
incline/viaduct

0 1 2 3 4 5 MILES

SCALE

Nanny Mayers
incline Whitehall Lanchester

Lanchester
Valley line to
Durham (1862)

Meeting
Slacks engine
Parkhead
wheel Waskerley Waskerley Deviation (1859)

Burnhill Junction

Weatherhill &
Rookhope Railway

Parkhead wheel
deviation (1847)
Parkhead

Weatherhill engine

Weardale Extension Railway (1845)

Hog Hill Tunnel Crawley engine

Crawleyside lime kilns

Deerness
Valley
line to
Durham
(1868)

To Bishop
Auckland,
Shildon and
Darlington

Tow Law

Stanhope
To Wearhead via
Wear Valley Extension
Railway (1895) River Wear Wear Valley Railway (1847/1862)

Wolsingham Sunnyside
deviation (1867/8)

Crook

Introduction

The Stanhope & Tyne Railroad Company (S&TR), which opened its railway in 1834, had a fascinating history, not only for how brief its existence was and its spectacular financial downfall but also for the fortunes of the railway companies that followed it and the changes they made. Originating at Lanehead limestone quarry at Crawleyside, Stanhope, the line planned to sell lime (from the company's limekilns) and limestone from its quarries, as well as sell coal (including from its own pits) and earn revenue from transporting other

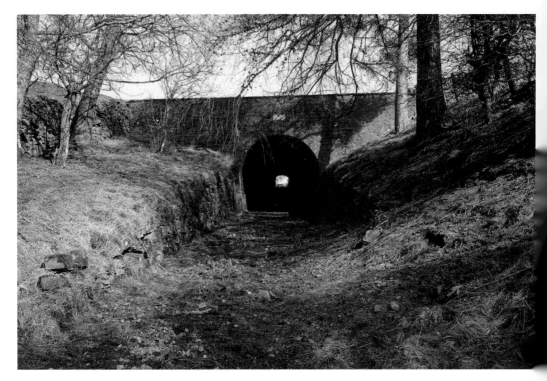

Hog Hill tunnel, Crawleyside, through which the Crawley incline ran, seen from the south A stone on the tunnel mouth marks the year of construction, 1833.

coal to the impressive large coal drops at South Shields, from where it would be sailed off to London or elsewhere. Despite being built to high standards and with none other than Robert Stephenson as consulting engineer and Thomas Elliot Harrison as resident engineer, it was not a success. The opening of the western section from Crawleyside to Annfield on 15 May 1834 was marred by tragedy when four wagons filled with forty to fifty passengers, mostly workmen, ran away down Weatherhill incline. The young man at the top of Crawley incline had little option but to divert it into a siding already occupied by loaded wagons, rather than the alternative of having it continue down the steeper Crawley incline where it would have caused greater destruction, especially as Hog Hill tunnel on the incline was 'literally filled with people'. The collision killed one man instantly, a nine-year-old boy died later in the day, and another man passed away from injuries several days later. Others were injured, including two or three suffering broken bones after jumping out of the runaway wagons. The cause listed in one newspaper report was that too much rope attached to the wagons had been paid out at the top of the Weatherhill incline, and when they started down the incline 'the engine was not set to work sufficiently soon to supply them with additional rope'. When the descending wagons naturally started to pick up speed as they journeyed downhill, there was a 'sudden check' as the rope jerked on the winding drum not moving quick enough for the shock. The 'sudden check' snapped the shackle attaching the rope to the wagons and they started their inevitable descent down the incline.[1] Even if the occupants were able to try and apply the brakes it would not be enough to stop them.

As the managing director, William Harrison, and William Teasdale (a young man who had worked for the four Mason brothers of West Auckland who had constructed part of the line from 1832) were going around the wounded, they found, next to a dead body, a man who also appeared to be dead. As he was lifted, the man opened his eyes, and after being asked how he was, responded 'Not so bad, but varra hungry'! According to Teasdale this was quickly arranged.[2] The accident had been preceded by a death three weeks before the opening, when a popular twenty-six-year-old man named William Marquis slipped when climbing off a wagon near Middleheads (between Cold Rowley and Hownes Gill) and was ran over by it, witnessed by his brother who was on another wagon in the train.[3]

In terms of the running of the line, the western half of the S&TR from Stanhope initially got off to a good start, with sixty chaldrons of lime reportedly leaving Crawleyside a day, and the S&TR was confident enough to build another set of six limekilns near Annfield at Bantling Castle, but their high hopes proved unfounded. Coal traffic on the eastern half of the line from Carr House to South Shields kept that section busy, but owing to the sales of lime being far lower than expected the section from Crawleyside to Carr House was closed in 1839. Other than the transport of lime and limestone, for which there proved to be little demand to recoup the expense of quarrying it, producing lime, and transportation of them, there was precious little traffic on this part of the line compared to the coal-rich district from Carr House eastwards to South Shields. The costs saved by closing half of the line were not enough to save the company – crippled with high debts from the building of the

1 *Durham County Advertiser,* 23 May 1834
2 *The Shields Daily Gazette and Shipping Telegraph,* 25 July 1899
3 *Durham Chronicle,* 2 May 1834

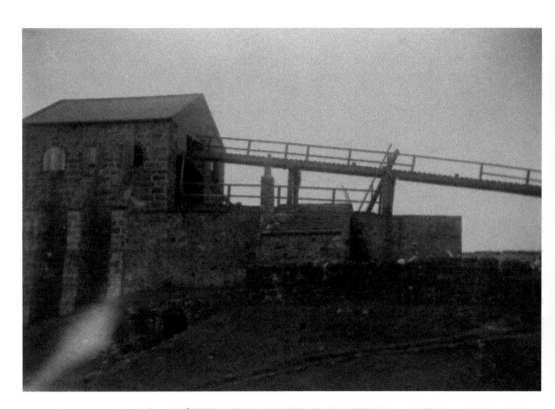

Above: Weatherhill
incline engine
house. (Richard
Charlton
Collection)

Right: Small
limekiln at
Crawleyside.
(Beamish Museum)

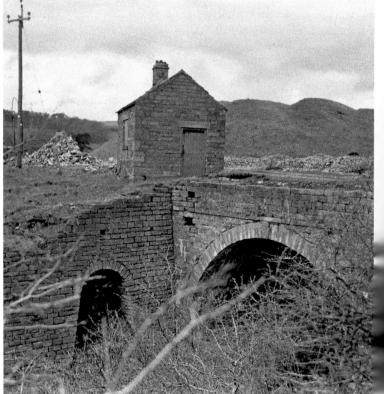

line, together with expensive wayleaves (the rent payable to landowners whose land the railway ran across). Despite successfully moving large amounts of coal from the collieries of north-west Durham the railway went bankrupt in early 1841. The eastern half was taken over by a new company formed by twenty-four of the original forty-nine shareholders, including Robert Stephenson, and named it the Pontop & South Shields Railway.

By a strange quirk of fate, a year after the western section of the line closed, the setting up of the Derwent Iron Company at Consett was to bring new life to this part of the line, and if it had been set up sooner could have changed the fortunes of the S&TR – alternatively if it had not been set up at Consett or had been slightly later, the section may have remained closed and just been a minor footnote in railway history. Limestone, and therefore the vast deposits of it nearby in the limestone quarry at Lanehead, were vital to produce iron at Consett. Limestone was needed as a flux in the blast furnaces, burnt together with coal and iron ore. The impurities in the iron ore stuck to the limestone, and as the works expanded so did the demand for limestone. The Derwent Iron Company initially approached the Pontop & South Shields Railway to request them to reopen the line from Crawleyside but the new owners were not interested, so instead the Derwent Iron Company purchased it from them and ran it themselves, needing only a short branch from the line at Carr House to serve the ironworks.

After two years of operation, the Derwent Iron Company approached the Stockton & Darlington Railway (S&DR) with a view to linking the line with their expanding network and taking it over. The S&DR, since opening in September 1825, had proved successful at moving large amounts of minerals – mainly coal – over long distances, building up a sizeable locomotive fleet to do so. Despite its name, the S&DR originated in West Durham

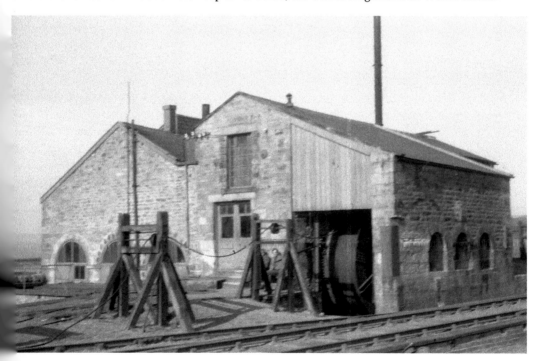

Crawley incline engine house. (J. W. Armstrong Trust)

near Bishop Auckland and had a sizeable works at New Shildon to build and maintain the locomotives and wagons needed, so was not far from the western half of the S&TR. In 1842 the opening of the Shildon tunnel enabled the S&DR to head deeper into West Durham and use locomotives west of Shildon for the first time, avoiding the incline planes at Brusselton and Etherley. Via the Bishop Auckland & Weardale Railway (actually a subsidiary company of the S&DR used to make expansion easier, a number of these were later created by the S&DR), the S&DR reached Crook, via Bishop Auckland, in 1843. The S&DR agreed to take over the western half of the Stanhope & Tyne and planned a route to join it from Crook via Tow Law – the Weardale Extension Railway (itself created by the Derwent Iron Company and formed by Act of Parliament in 1843) – to the former S&TR near the head of Nanny Mayer's incline. This led to the creation of an important railway junction at Waskerley. The former S&TR line would be known as the Wear & Derwent Railway, although it sometimes appears as the Wear & Derwent Junction Railway.

The naming of this book *The Wear & Derwent Railway* clarifies the book's subject as focussing on the post-S&TR history of the western half of the line, the section from Crawleyside via Waskerley to Carr House, covering in detail its history after it was taken over by the S&DR. This follows on from *The Stanhope & Tyne Railroad Company* (Amberley Publishing, 2020), which focusses on the operations of the builders and original owners of the line. Other lines in the area are necessarily mentioned as when it became part of the S&DR, and from then on, the railway was not operating in isolation and there was through traffic to these lines as well as limestone to the ironworks at Consett. The work done by the S&DR to improve the line after its takeover are just as fascinating as its construction by the S&TR, and is extremely well preserved today. To be up on the moors on the surviving track bed it takes little imagination to think of one of Timothy Hackworth's double-tender Tory class locomotives, which were strongly associated with the line, making its slow labourious way with a heavy train of loaded wagons, seemingly an imposter among the bleak landscape where even fencing did not feature, the trains appearing from a distance to be travelling across open fields.

It almost seems impossible that such a railway could have existed in such a harsh environment, and at such an altitude it feels as if you are on top of the world, and certainly the high winds, prevalent there most of the time, give that impression too. The aim of this book is to capture something of the atmosphere of this railway, detail the changes that occurred here by the S&DR, which transformed the railway, and tell the fascinating and often tragic history of what happened along it.

The Wear & Derwent Railway

Following investigations in 1839 into ironstone in the Consett area (known then as Conside), in 1840 four men set up the Derwent Iron Company and erected two blast furnaces, as well as acquiring mineral leases in the area to mine for the raw materials needed[4]. The Derwent Iron Company took over the line in 1842, purchasing it together with Lanehead Quarry from the Pontop & South Shields Railway, who had taken over from the S&TR in 1841 (the Pontop & South Shields Railway received an Act of Parliament in 1842, unlike their predecessor) but were not interested in reopening the section from Crawleyside to Carr House. From what is known of the line under the ownership of the S&TR, little changed under its new management. An accident in July 1842 occurred on the Crawleyside incline when three loaded wagons ran away and derailed – one of the wagons, the last to derail, leaving the rails where the line curved towards the limekilns at Lanehead quarry and decapitated one of three children crossing the line at this point, bruising another[5, 6]. Aside from this horrific incident, for the next few years operation likely continued in a fairly routine manner, simply moving the lime and limestone up over the moors and passing empty wagons or those loaded with coal for the limekilns coming the other way.

The line started at the limekilns at Lanehead Quarry, Crawleyside, to the north of the town of Stanhope in the Wear valley. A report by Joshua Jenkinson for the S&DR dated 30 May 1844 describes them and their production capability:

> There are 19 Kilns at Stanhope – 7 larger and 12 smaller ones. The large kilns when first filled held from 16 to 18 wagons of clot lime and take about 8 wagons of coal:- they are capable of producing when regularly drawn from 4 to 5 wagons of clot lime daily, and require about 2 wagons of coal daily to maintain that supply. The smaller kilns take from 6 to 8 wagons of clot lime when first filled, and take from 4 to 5 wagons of coal:- they are

4 Warren, K., *Consett Iron 1840 to 1980, A Study in Industrial Location* (Oxford: Clarendon Press, 1990) p. 6

5 Richardson, M. A., *The Local Historian's Table Book Historical Division Volume V* (Newcastle: MA Richardson, 1846) pp. 388–89

6 *The Railway Times*, Volume V, No. 30, 23 July 1842

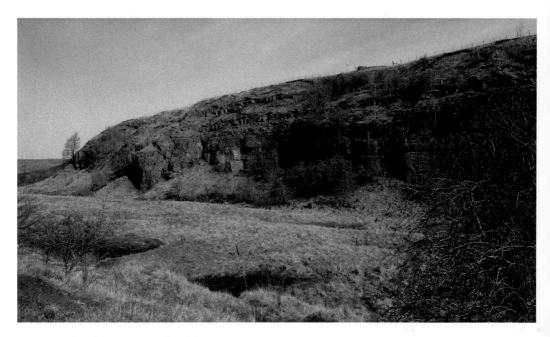

Lanehead quarry, Crawleyside.

capable of supplying when regularly drawn from 1 ½ to 2 wagons of clot lime per day, and require about 1 wagon of the best description of coal they use daily. The three different kinds of coal are small coal or calm, Crook Hall Coal & Conside Coal , of these three the Conside Coal is the best.[7]

The terminology used is confusing to modern eyes, i.e. the use of loading it with clot lime then producing clot lime after being burnt with coal. Presumably, Jenkinson is using 'clot lime' to describe both the limestone the kilns were loaded with and the lime drawn from the kiln that was sold for agricultural or construction use. 'Calm' coal refers to very small coals. The remains of the limekilns were recorded in detail by industrial archaeologist Frank Atkinson in the 1960s, who believed it was likely the larger limekilns were built by the S&DR, although Jenkinson's report states large kilns were already present in 1844 meaning these were likely built by the S&TR or Derwent Iron Company. Large oval limekilns had certainly been built by the S&TR at Bantling Castle, near Annfield Plain, similar in size to the largest seen in images of those surviving at Crawleyside in the 1960s. Little remains today of the limekilns at Crawleyside, which have since been built on, although at least one small limekiln survives and is visible from a public footpath. T. E. Rounthwaite described the kilns in his 1965 *Railways of Weardale*:

These are believed to have been restarted after forty years of inactivity by two local men, Messrs. Beaston and Johnston, probably in 1938 and they have continued to operate four or five of the original seventeen kilns ever since.

7 TNA RAIL 667/221 Reports from Joshua Jenkinson on the lime works and railways near Stanhope

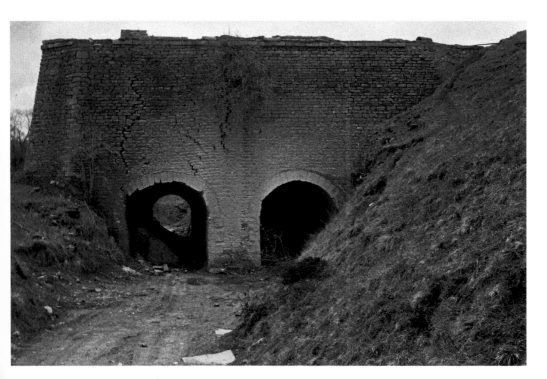

Above: Large limekilns at Crawleyside. (Beamish Museum)

Left: Wagons passing on the Crawley incline between the kilns at Lanehead quarry and Hog Hill tunnel. (Kind courtesy of Chris Freeman, not to be reused)

Whether or not these are the original 1834 kilns is open to question, some have certainly been demolished, though those still in action appear to stand on the site of the early kilns and their massive structures are not without fissures[8] Looking at maps of Crawleyside it appears there could have been up to seventeen of the smaller circular kilns in three separate rows, and the larger structure could have held seven or perhaps even nine kilns. His description of seventeen original kilns is also interesting.

8 Rounthwaite, T. E., *The Railways of Weardale* (Railway Correspondence and Travel Society, 1965) p. 24

Whatever the number of original kilns built by the S&TR and how many of these were modified or added to by the S&DR and future owners, the scale of lime making at Crawleyside was clearly an impressive operation, shown by their imposing nature in these images.

Five months after Jenkinson's report into the limekilns, William Bouch, chief engineer of the S&DR (following Timothy Hackworth's resignation in 1840) reported on the line itself, which gives a fascinating insight into the operation of the line at this time and the route it took.

Immediately from the limekilns there was the foot of the Crawley inclined plane, 934 yards long with the steepest part being a gradient of 1 in 7. It worked two wagons at a time but could do three, with a capability of 120 to 140 wagons in a long day of fourteen hours. It used a single track, Bouch recommending that it could easily be doubled by putting down additional rails like a self-acting incline so that two sets of wagons could be worked at a time (one going uphill, the other down). As well as additional rails, it would require another rope roll for the engine, Bouch also noting that the masonry of the engine house was already arranged for its adoption, and about half of the required machinery for the change was already there. It was worked by a 50 hp high pressure steam engine built on the 'George Stephenson plan' by Hawks of Gateshead, with a cylinder 2 feet 4 inches in diameter with a 6-foot stroke. It was described as in very good working order, powered by two tubular boilers, 25 feet long and 6 feet in diameter, with a firetube of 3-foot diameter. They were in good order and burnt small coals, which produced plenty of steam, and although had been in situ for ten years, owing to the closure of the line from 1839 had only worked for about six years, so were due for repair in two or three years. There was one engineman at Crawley with one bank rider for riding the sets of wagons up and down the incline.

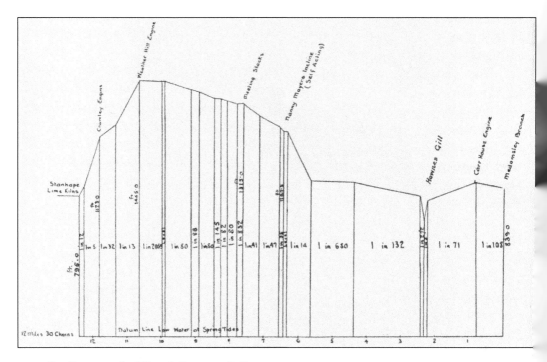

Gradients on the Wear & Derwent Railway.

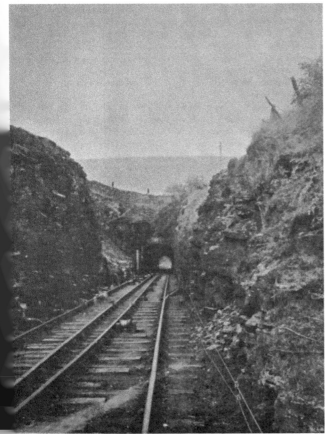

Above: Crossing on the Crawley incline, south of Hog Hill tunnel. (Kind courtesy of Chris Freeman, not to be reused)

Left: The north portal of Hog Hill tunnel on the Crawley incline.

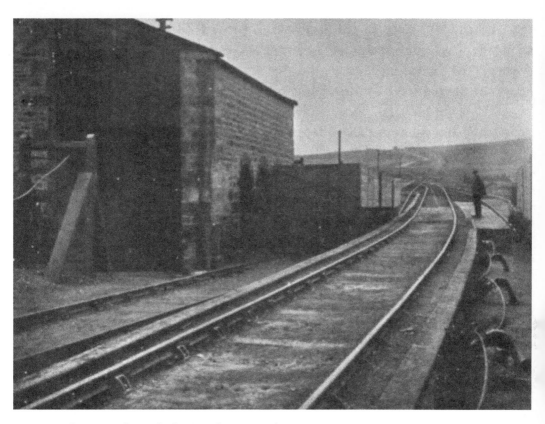

Set of wagons alongside the Crawley engine house.

Immediately from the head of Crawley incline, at the engine house, began the Weatherhill incline, again single track, 1 mile and 128 yards long but not as steep, the steepest gradient being 1 in 10. It worked four wagons at a time but could do six and could be doubled in the same way as the Crawley engine. The incline was worked by a 50 hp high pressure Hawk engine with a cylinder 2-foot 4-inch diameter with a 5-foot stroke, again in good working order and with two boilers identical to those at Crawley. As well as the engineman and bankrider, a fireman was also employed here, and best coals were used but it was often scarce of steam.

The amendments to the Crawley and Weatherhill inclines to double them by adding rails and other equipment so two sets of wagons could be moved a time was presumably put in place fairly soon after the S&DR took over. An undated, but believed to be c. 1850, specification for mason's work exists for constructing room for an additional boiler at Crawley[9].

The head of Weatherhill incline was the summit of the line at 1,440 feet above sea level. The next section of line descended 354 feet in the 3 miles and 352 yards from Weatherhill incline head to Meeting Slacks engine. When it opened, the section was worked by horse on the relatively level section between Weatherhill to the Parkhead wheel. This was a

9 CP/Shl 11/5 Durham County Records Office

horizontal wheel that had the wire rope from the Meeting Slacks engine returned round it and attached to the rear of sets of wagons for lowering them down to the Meeting Slacks engine. The Derwent Iron Company, to save costs, removed the horse-working here and instead from the beginning of 1844 ran a wire rope that was attached to the Weatherhill and Meeting Slacks engines. Each engine worked separately, pulling the sets of wagons towards itself. The Weatherhill engine, pulling the sets of wagons (which consisted of twelve wagons at an average speed of 9 miles per hour) uphill towards itself with gradients at their worst of 1 in 31 and 1 in 33, struggled with the additional load, which it was not intended for when built. It is unsurprising then that despite using best coals it still struggled with steam. The changes of gradient experienced in this work also caused sudden changes in speed of the sets of wagons, which made the rope jerk off the roller sheaves that kept the wire rope on course and moving as frictionless as possible, and stopped the rope fouling the track. The throwing off of the rope caused grinding and tearing of the ballast and sheave frames, as well as additional resistance from the engine by this friction. Bouch recommended that the most efficient remedy of this would be converting the section into one suitable for locomotive working. The additional strain placed on the engine doing this work could have contributed to it being reported unsafe a year into the S&DR's operation of the line on 1 January 1846, the bolts of the bottom centre not being fastened to the wall, which was 'threatening to bring the place down'.[10]

Weatherhill engine house. (Richard Charlton Collection)

10 TNA RAIL 716/11

The Meeting Slacks incline, running for almost 3 miles from the Parkhead wheel, continued downhill past the engine house, which was located approximately halfway along its length, although at the engine house the rope was taken off the sets of wagons and another attached for lowering down to the head of Nanny Mayers bank. The incline was self-naming – the sets 'meeting' in the middle, where the engine house was, with the ropes then 'slack' to be removed and another rope attached. The Meeting Slacks engine was a Hawthorn-built 40 hp high pressure engine with a cylinder, 24 inches wide with a 5-foot stroke, described as being in excellent working order. The two boilers used here were described as 'egg shaped' – although 'ended' rather than 'shaped' would probably be more accurate – 30 feet long with a 6-foot diameter. It had been thoroughly repaired in spring 1844 and, burning small coals, produced plenty of steam. There was one engineman and fireman employed here, as well as a boy at the rope rolls and two bank riders, one riding the sets to Weatherhill and one to Nanny Mayers bank. The inclined plane between Meeting Slacks and Nanny Mayers was 1 mile 453 yards long with the steepest part being 1 in 26, the slightest 1 in 58, and could work eight wagons at a time. The foot of Meeting Slacks incline, and the head of Nanny Mayer's incline, was near where the meeting was made with the Weardale Extension Railway.

Nanny Mayer's incline was a self-acting incline (the only one on this half of the line, but one of five on the entire S&TR when it opened in 1834 with the others running from Stanley to Stella Gill on the eastern half) whereby the greater weight of a set of loaded wagons going downhill pulled up, using a wire rope attached via a brake wheel at the head of the incline, a set of empty (or lightly loaded) wagons. The two sets of wagons would pass each other at a meeting halfway along the incline. The incline's namesake Nanny Mayer, or Mayor (the headstone of her husband and several children states 'Mayor' but it is clearly down as 'Nanny Mayer' on maps) was born in Wolsingham in 1775, marrying John Mayer in 1800 at Muggleswick, living at Tween House, about a thousand yards north-east of where Waskerley village was to spring up. The incline, which ran from Waskerley north-eastwards on its descent down towards the Tyne, was just over 50 yards from Tween House, and the enterprising Nanny Mayer sold ale to the railway workers. The name 'Nanny Mayers Incline' or spelling variation thereof stuck. Tween House became the Railway Inn, and Nanny Mayer passed away in 1860[11]. Nanny Mayer had seven children who died before her, but a grandson, William, became a successful ironworker in Dumbarton, Scotland, who fitted a headstone to her grave in 1889, gates to the churchyard in 1897 and railings around the grave in 1919.

The incline was 1,122 yards long with gradients between 1 in 10 and 1 in 13, and worked eight wagons each way at a time with one brakesman and one bank rider employed. As it required a set of wagons to act as a counterbalance for loaded wagons going downhill, it proved a bottleneck as loaded wagons at the top of the incline had to frequently wait for two or more hours for a return load, which caused back-ups further along the line towards Stanhope, described as a 'mischevious hindrance' by Bouch as there was 'insufficient means of getting the return or empty wagons back'. Bouch mentioned that when the Weardale extension was opened, and traffic would hopefully increase and divide itself at the top of

11 DCRO Library Pamphlets Vol C 8/4, Sobo, M.E., *Muggleswick and Waskerley – an eclectic history with photographs*

View of Waskerley showing the trackbed of Nanny Mayer's incline running down from Waskerley.

Nanny Mayers bank to either go on to Stanhope or towards Consett, then there should be an improvement in maintaining the numbers of wagons ascending and descending the incline. He also mentioned that the use of a stationary steam engine would 'become practically necessary', suggesting the use of the Meeting Slacks engine when dispensed with by the introduction of locomotive power on that section, although this never seemed to have been implemented.

The next section, 3 mile 385 yards long from the foot of Nanny Mayer's incline to Hownes Gill, was almost level for 2 miles and 699 yards then slightly descended for the final 1,446 yards to Hownes Gill. It was worked by horses, which were described as 'the cause of many delays', although a 'light locomotive' could easily be utilised instead with good facilities for watering nearby and the main outlay being in the laying of new rails and sleepers. The S&TR was described as using Dandy Carts on the 1,446-yard downhill section, which were small wagons at the rear of a train of wagons that a horse would ride in to save energy on downhill sections so the horse could work a longer day. These are not mentioned in the report so may not have been used by the Derwent Iron Company, or perhaps Bouch did not think their use was worth mentioning.

Hownes Gill is a large ravine, and the location of another bottleneck. The S&TR used an elaborate method of working for getting across as a viaduct was not originally built, owing to expense, and complicated by soft ground at the bottom of the gill. Instead, two steep inclined planes with cradles to keep the wagons level were used. Worked by a single stationary steam engine at the bottom of the gill, the engine was assisted by the weight of a wagon descending

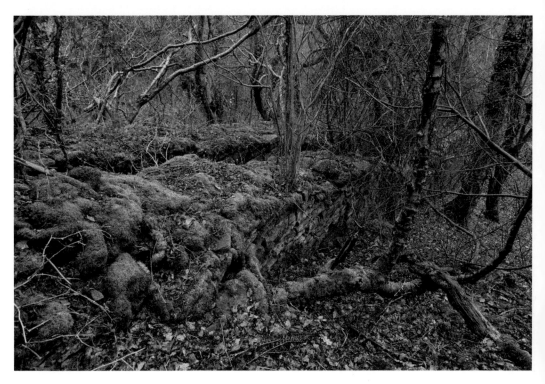

Remains of Hownes Gill inclined plane on the Consett side of Hownes Gill.

one side of the gill to move the wagon on the opposite side upwards. One side of the incline was 147 yards long, the other 146 yards, rising 15 inches to the yard and gaining a vertical height of 62 yards. The wagons were moved sideways on the cradles, the steam engine moving the cradles by endless ropes. The engine was a 25 hp high pressure engine built by Robert Stephenson & Co. with a 20-inch diameter cylinder with 5-foot stroke described as in very good working order. The engine was powered by a single boiler, 25 feet long, 6-foot diameter with a 3-foot diameter fire tube. A new bottom was put on the boiler in the spring of 1844 and was in very good working order, burning small coals with steam sometimes being scarce. There was one engineman and six banksmen, two at the bottom and two at each incline head.

There were eight small turntables – when a wagon was received at one side of the gill it was turned through 90 degrees, placed on the cradle, ran off at the bottom onto another turntable for moving across the platform past the engine house, and the process repeated in reverse for the ascent. The Hownes Gill incline could move 120 to 140 wagons per twelve hours, but in 1844 the traffic on this part of the railway was already nearly equal to the capacity of the inclines so any increase in traffic would require improvements. Bouch suggested building a tension iron viaduct on the plan of the 'Auckland & Weardale Occupation Iron Bridge' on four stone pillars, with four equal spans of 53 yards each, but the masonry alone could cost £7,000 and he estimated the entire structure would cost no less than £10,000 – another option would be creating a culvert and filling in the gill with an embankment, which would cost between £10,000 and £12,000. An advert for £30 for the best plan or working drawing and an estimate to construct a bridge, and £10 for the runner-up, appeared in newspapers in late 1844, the plans or estimates to be delivered to

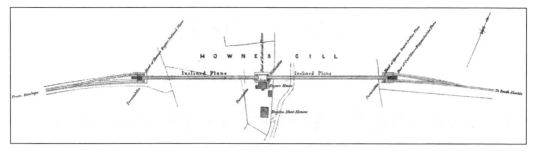

Diagram showing how the Hownes Gill inclined planes worked.

Emmerson Muschamp of the Derwent Iron Company at Lanchester Lodge, with S&D civil engineers John Dixon and John Harris to judge them.[12] There were forty entrants with the winner being a John Henderson, engineer and architect of Newcastle, but construction did not take place.[13]

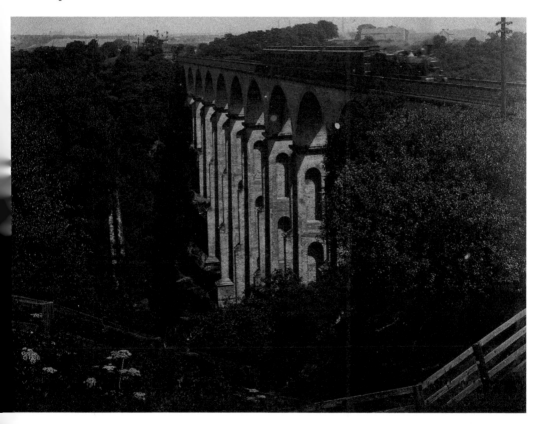

View of Hownes Gill viaduct with a passenger train crossing, showing the remains of the inclined plane through the trees to the left. (Kind courtesy of Neil Raine, not to be reused)

12 *Leeds Mercury,* 7 December 1844

13 *Newcastle Courant,* 28 February 1845

An early description of the Hownes Gill inclines comes from an unlikely source – *The Spas of England, and principal sea-bathing places* by A. B. Granville:

Two sides, N.E. and S.W., nearly, of an immense chasm or ravine have been made available in the direct line of the railway to and from Stanhope, without bridge or embankment or viaduct, by means of a very ingenious arrangement in virtue of which the travelling trains are made to slide down one side, and mount the opposite one, through the operation of a stationary engine, of twenty- five horse power, placed on a platform quite at the bottom of the chasm. The latter is one hundred and eighty-eight perpendicular feet in depth, and its two sides stand at right angles with each other, having each an inclination of thirteen inches for every three feet, to an extent of one hundred and fifty yards.

The train of wagons, loaded with lead or lime, proceeding from Stanhope in the western district, or another train coming from Newcastle in the opposite direction with coals, having reached the termination of the level ground on either side of the ravine, is suddenly stopped, and the foremost wagon (for only one at a time can be operated upon) being unyoked, is turned upon a circle with its side towards the precipice, and slided forward and fixed into a moveable platform. The latter is in waiting on the very brink of the precipice, resting upon the rails with its four wheels, the two foremost of which being of larger diameter than the hind ones, cause the said platform to continue in an horizontal position while sliding down one incline, or ascending the other opposite, with its loaded wagon.

To such as dread the sight of a deep abyss, this rapid manouevre, performed by a single man, aided by a little boy, who launch down its precipitous side a ponderous load, restrained only by an endless strap in its downward descent, is a spectacle highly exciting to the nerves. Though invited, I had not the courage to commit myself to one of these headlong messengers. One time I had placed my foot on the platform ready to descent with one of them, merely in hopes of seeing afterwards the effect or sensation produced by the ascending train. That sensation is said to be exactly like that experienced in a balloon while mounting into the air. But I contented myself with seeing and admiring the beautiful twofold movements of the ponderous cars.

'Steady and swift the self-moved chariot went
Winning the long ascent,
Or downwards rolling 'gainst the furthest shore.'

These trains of lime-wagons from Stanhope, coming to exchange that commodity for Newcastle coals, load in the great quarries at the former place. The limestone is a species of brownish or dark bluish-gray marble, with bivalve shells, taken from the great Stanhope limestone bed, consisting of three strata, divided by indurated clay. The quantity quarried there, either for building-cement or ornamental purposes, or for agricultural uses, is exceedingly large.'[14]

14 Granville, A. B., *The Spas of England, and principal sea-bathing places – Northern Spas* (London Henry Colburn, 1841) pp. 309-12

A few years later it was visited by railway and industrial dignitaries hosted by the Derwent Iron Company:

The Travellers spent an hour at Consett, taking lessons in the manufacture of iron from the ore. There are now two furnaces in operation – other two nearly completed – and a fifth and sixth in embryo. The works are the property of the Derwent Iron Company – who have also purchased that portion of the Stanhope and Tyne Railway which runs westward from the Medomsley Branch. The party proceeded from Consett to Houndsgill, to witness one of the most wonderful railway-rarities in existence. The Stanhope and Tyne Company had to pass a gully or ravine, 50 yards deep; and the question was, 'By what means should the feat be accomplished?' A bridge seemed the most suitable means. But the engineer – tempted, probably, by a desire to display his skill, and the powers of his art – adopted the expedient of two inclined planes! When the Gatesiders and their friends, on Tuesday last, approached the edge of the narrow valley, they were struck with astonishment to see wagons laden with lead, the produce of the Silvertongue mine, descending from the opposite side, and rising to the platform on which they stood. Some of them – in whom schoolboy sport and enterprise were not yet extinct – clung round a wagon, and enjoyed a semi-circular ride from east to west, and from west to east. It was suggested by one of them, that it was the very place for a 'centrifugal railway,' and that the adoption of this principle would save the expense of the steam engine at the bottom of the ravine. It is probable, however, that the new proprieters of the railway, when they do make a change, will resort to the expedient of a bridge.[15]

Aside from apparently not being aware of the true reasoning for the inclines rather than a bridge, the description – and that by Granville - are also interesting for the mention of lead traffic on the line of which little definite is known, although 'lead bogies' are described as used on the line in early years[16].

From the Consett side of Hownes Gill incline the wagons were attached to a rope from the Carr House engine, a 50 hp high pressure engine built by Robson of Gateshead, with a cylinder 2-foot 4-inch diameter with a 6-foot stroke, described as in good working order, and powered by two boilers 25 feet long, 6-inch diameter with 3-foot diameter tubes. The tubes were new, and new bottoms had been put on the boilers in the spring of 1844, with them burning small coals. The incline from Hownes Gill up towards the engine was 1 mile and 779 yards long with twelve wagons at a time. The engine also worked the descent down towards Medomsley, 812 yards long, again with twelve wagons at a run. Bouch described how the engine 'now works three planes with one rope', which sometimes required it to run at 'high & destructive speeds'. The third bank was not mentioned but was possibly to the Derwent Iron Company's works, which were located to the north of the line between Hownes Gill and Carr House engine and accessed by a reversal from the Carr House engine for any traffic that came up the Wear & Derwent line. There was one engineman, one fireman, one boy 'at the rolls' and two bankriders employed at the Carr House engine.

15 Douglas, W., *Local Collections; or, Records of Remarkable Events connected with the Borough of Gateshead* (Gateshead: Observer Office, 1843) pp. 133-4

16 *The Shields Daily Gazette and Shipping Telegraph*, 25 July 1899

Snowplough train on what was the Carr House west incline to the north of Hownes Gill, with the later line to Consett South junction from Hownes Gill Junction going to the left. (Beamish Museum)

Bouch's remarkably detailed report gives a strong impression of how convoluted the working of the railway was[17]. Joseph Pease of the S&DR was told by traffic manager Ralph Robinson that the working of the line owing to the numerous inclines 'was like a lot of fiddlers playing a concert, if one made a mistake it spoiled all the rest'[18].

Bouch made numerous recommendations for locomotive working to greatly ease the working of the line, which would come to transform the appearance and route of the line over the next fifteen years.

17 TNA RAIL 663/1 Report from William Bouch re the engineering features and mode of working from Crawley Incline to Hownes Gill, 1844
18 TNA RAIL 667/427

Rebuilding a Railway

To make it suitable for locomotive working and avoiding as many inclines as possible, the S&DR had a huge task ahead of them. The S&DR – under the guise of the Wear & Derwent Junction Railway (an encompassing name which included the operation of the Wear & Derwent and Weardale Extension line) – took over the line on 1 January 1845 and bought it, including the limestone quarries for £40,000, from the Derwent Iron Company.[19] It linked to the S&DR with the opening of the Weardale Extension Railway from Crook to Waskerley on 16 May 1845, having started construction the previous June[20]. To smooth out gradients and build deviation lines would need manpower, and lots of it – notices for 200 to 300 excavators wanted on the line were advertised locally in April 1845.[21, 22] There was a strong need to increase the capacity of the line to move more limestone to Consett – by 1845 the Derwent Iron Company had six blast furnaces and could produce 400 tons of iron a week. The following year there were eight blast furnaces and six more were about to start work.[23] There was also the need to house the locomotives somewhere and provide water for them. The men who would operate the railway and their families (who may also have been involved in working on the railway) needed housing, and in a rural area would need other needs met such as places of worship. The hub for this would be Waskerley, where the Weardale Extension Railway joined the S&TR route. An advert was issued by John Middleton, architect to the S&DR, in July 1846 for tenders to build cottages at Waskerley for workers, two rows being constructed, as well as a few other houses that comprised this high-altitude village.

19 TNA RAIL 527/171
20 Proud, J.H., *The Chronicle of the Stockton & Darlington Railway to 1863* (North Eastern Railway Association, 1998) p. 29
21 *Newcastle Courant*, 4 April 1845
22 *Newcastle Courant*, 11 April 1845
23 Warren, K., *Consett Iron 1840 to 1980, A Study in Industrial Location* (Oxford: Clarendon Press, 1990) pp. 6-9

Over the next few years, a station building was constructed that included the offices of the Wear & Derwent Junction Railway, as well as an engine shed, wagon repair shop and goods shed. A Methodist chapel catered for the residents' spiritual needs, although with regards to other spirits, there was no pub – after all, the S&DR was run by Quakers – although Nanny Mayer's Railway Inn likely flourished owing to its relative proximity to Waskerley in the absence of closer alternatives. An Anglican church, St Matthew's, was built in 1896 and the surviving Methodist chapel may post-date it, although the original Primitive Methodist chapel is listed in the 1851 Census of Places of Public Religious Worship. In October 1848 the residents of Waskerley asked for 'encouragement and support' from the Directors of the S&DR for a mechanics' institute and reading room. For the children of the workers there was a school, with the teaching staff paid for by the S&DR, later continued by the North Eastern Railway (NER) when they took over the S&DR. This remarkable railway community at 1,100 feet above sea level was well known for its hardiness.

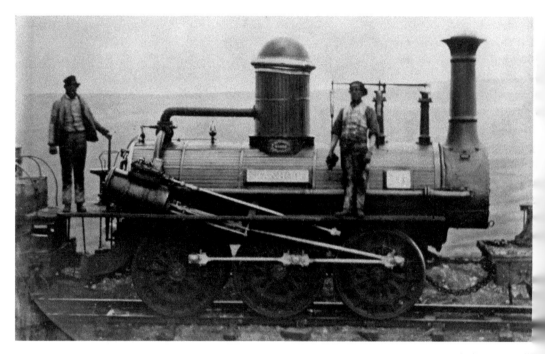

Tory class locomotive No. 16 *Stanhope* in a very early image believed to have been taken on the line. A copy of it, printed with it in the February 1920 edition of the *NER Magazine*, had the caption 'WE reproduce a photograph of a quaint old engine, the original of which was taken on tin before photography attained its present stage of perfection. The picture, however, is none the less interesting on that account. We do not remember having seen an older actual photograph of a locomotive. The only information we have received about the engine is that it ran between Weatherhill and Waskerley (the highest altitude on the N.E.R.), and was apparently one of the old "colliers" of the S. and D. period; also that the driver was Mr. W. Graham (at rear of engine), father of Mr. Wallace Graham, locomotive foreman, Durham, and the fireman, Mr. W. Shaw'. (Kind courtesy of James Waterman, not to be reused)

The growth of the ironworks at Consett saw a commensurate rise in quarrying at Crawleyside shown by an advert issued on 7 October 1846:

TO QUARRYMEN.
WANTED, a NUMBER of MEN at the Quarries and Lime Kilns, near Stanhope. Constant Work and Liberal Wages will be Given.

Application to be made either to Mr RALPH ROBINSON, Waskerley Park Station, Wear and Derwent Railway; or to Mr T. MADDISON, MR J. EMMERSON, and Mr JOHN BULLEY, at the Quarries and Lime Kilns, Stanhope.[24]

Additional traffic to the line followed the formation of the Weardale Iron Company, with a branch built and operation by them (after the S&DR declined to) from Rookhope to the Wear & Derwent line at Parkhead in 1851 and opening the following year.[25] The Weatherhill & Rookhope ran in an almost straight line to Bolts Head across the moors even higher than the Wear & Derwent, reaching an altitude of 1,600 feet above sea level. At Bolts Head there was a stationary engine-worked inclined plane that ran down to Rookhope. Despite its length and proximity to the S&DR it was operated privately with the wagons being picked up by the S&DR (later the NER) at Parkhead until it closed in 1923. Rails started to extend up the Wear Valley at the same time as the S&DR took over the former S&TR line – in 1847 the Wear Valley Railway, yet another S&DR subsidiary, reached Frosterley from Witton (later Wear Valley) Junction. The Wear Valley Railway, formed by Act of Parliament in 1845, was amalgamated in July 1847 with the Bishop Auckland & Weardale, the Wear & Derwent, the Weardale Extension and the Shildon Tunnel Company – then promptly leased by the S&DR in September and purchased outright in 1858.

The first major change to the original route was to avoid the Parkhead wheel and its use of the main-and-tail system. Rather than wagons from Parkhead heading on a straight course to the wheel, take a tight turn at the wheel then straight to Meeting Slacks, a gently curved deviation was constructed at a lower elevation between the site of Parkhead station and a point almost halfway between the Parkhead Wheel and Meeting Slacks engine house. This involved the creation of a large, lengthy embankment, and on the original route that was retained, a cutting was created to maintain the level. This was named the Frosterley Cut despite being some 5 miles from that town – although with no other locations nearby it was perhaps named after the nearest settlement due south. At some point in its life the cut was provided with a wall built of stone sleepers, supplemented by a short section of wooden sleepers, on the north side of the cut to protect against snow drifts. A similar but shorter section of stone sleeper wall was constructed east of Waskerley on the Weardale Extension Railway, and also surviving is a wall of wooden sleepers at Weatherhill incline head sidings.[26]

As well as men with hand tools, wagons were needed also to move material in the work to improve the line, with there being 165 earth wagons on the Wear & Derwent Railway recorded on 21 May 1847. Of that large amount, only thirty-four were in 'working order', forty-nine of

24 *Durham Chronicle*, 9 October 1846
25 Bate, E, Blackburn, A, Forbes, I, 'Rookhope Railway Dating Errors: 1851 not 1846' in *North Eastern Express* Volume 61, August 2022, No 247
26 TNA RAIL 667/59

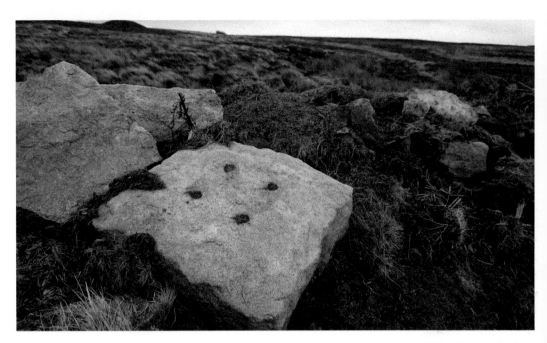

One of many stone sleepers remaining alongside the trackbed. The four holes show where an iron rail chair would have been placed, holding the rail on top. These were later replaced by wooden sleepers.

them having 'bad bodies and wheels', forty-eight wanting 'much repairing' and thirty-four wanting 'a little repairing'.[27] At least one man was killed during the work on the deviation:

> The engine and wagons were proceeding as usual from Meeting Slacks to Parkhead, the rope in connection with the Meeting Slacks engine having been attached to the train.
>
> When the train arrived at the switches ... which form a connection between the new Railway and the present one, a wagon laden with blocks had to be detached at that point, and in consequence of the man named Caleb Armstrong not uncoupling the wagons at the proper time, the back end of the block wagon came in contact with the last wagon of the train, after the former had taken the switches, and the man was thereby thrown off. The laden wagon passed over his body and death took place almost immediately after.
>
> No blame could be attached to any other person than the deceased. He has left a widow and 2 children.[28]

Other work included the provision of water for the locomotives working the line. A water crane was built in 1847 between Parkhead and Weatherhill, providing the only source of water for locomotives for the line after the column at Waskerley engine shed.[29] Built at a

27 TNA RAIL 716/11 Correspondence re. working of lead and lime traffics
28 TNA RAIL 667/1228 A file of letters concerning the working of limestone and lead traffic from Waskerley Park 1846-1847
29 Teasdale, J.G., *Servicing the North Eastern Railway's Locomotives* (North Eastern Railway Association, 2007) p.50

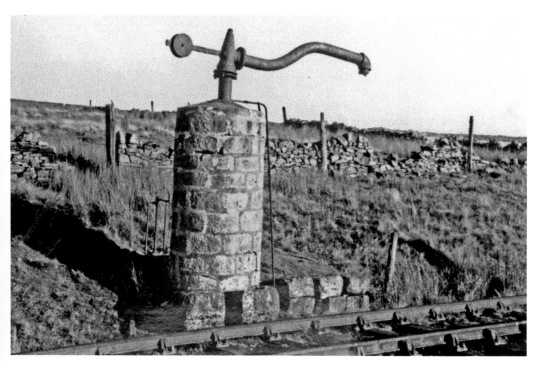

The water crane built by the S&DR between Parkhead and Weatherhill in 1847. (Beamish Museum)

cost of £11, 2s and 6½d , it was clearly built with appreciation of the weather conditions it would have to endure. The main section of water pipe had cork wrapped around it, and then surrounded by stone to give protection against the low temperatures that were frequently experienced at its location. A 1-inch pipe from the main pipe, just above where it left the protection of the stonework, ran down to the ground for draining off water in freezing conditions. A gap in the base of the stonework allowed for a fire to be placed in to either keep it working, or to de-ice it when needed. Although the original survived long enough to be photographed and surveyed in the 1960s, it was since demolished, but the reservoir which fed the water tower is still present and a replica exists at the Pockerley Waggonway at Beamish Museum.

The 1.5-mile-long deviation line avoiding the Parkhead wheel was completed at the end of 1847, allowing locomotive working along the entire length of the line from Waskerley to the head of Weatherhill. The deviation never strayed further than 200 yards from the original route, although at its midway point was significantly lower than the original route, slowly climbing to meet the original route at Parkhead from the Waskerley direction. Both routes can still clearly be seen, although the original route via the Parkhead wheel is much fainter and, in some parts, heavily waterlogged. The section between Waskerley and Weatherhill was known as the Parkhead level, with the section from Nanny Mayers called the Rowley level. The Weatherhill and Crawley inclines were to remain until closure, as owing to the gradients there was no way of allowing locomotive working on that section. In 1847 the self-acting Nanny Mayer's incline remained, as did the inclines at Hownes Gill. It is not known for how long the Carr House engine remained in service; however, the incline's slight gradients would easily allow for locomotive working and locomotives

are certainly known as having worked around Carr House in the early 1850s. The Rowley level swiftly changed to locomotive working after the improvements suggested by Bouch. A station was built at Parkhead with goods facilities and a coal depot to serve the rural community – although sparsely populated, the facilities for coal and goods created by the S&DR at Parkhead and at Waskerley would be vital to the rural communities in the area, supplementing the coal and lime depots built by the S&TR.

Right: 1848 handbill advertising the sale of coal from Parkhead.

Below: Coal depot, believed to be originally built by the Stanhope & Tyne Railroad, at Crawleyside.

COALS.

The Public are respectfully informed that Coals may now be had at the PARK-HEAD DEPOTS, near Stanhope, either by the Wagon or by Cart, at the following prices :—

BY THE WAGON—

	£.	s.	d.
BEST COAL - - - -	0	14	0
UNSCREENED COAL - -	0	13	0
NUTS - - - - - -	0	12	0

BY CART—

			Per BUSHEL.
BEST COAL - - - - -	0	0	2¾
UNSCREENED COAL - -	0	0	2¼
NUTS - - - - - - -	0	0	2¼

Waskerley Park, May, 1848.

J. READMAN, PRINTER, DARLINGTON.

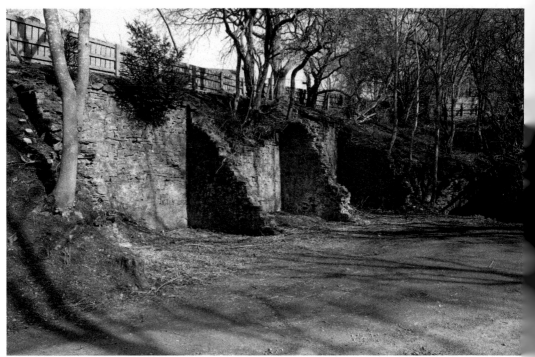

Feeding the Ironworks

The need for limestone was such that the Derwent Iron Company instructed the S&DR in July 1847 to haul wagons for them at any hour, and if no wagons were available at six in the morning when work should start, then for the staff to wait for them until they were, to hasten their delivery to Consett. On 12 July this was done, the railwaymen at Carr House waiting five hours, at which point just nine wagons appeared. The situation regarding delivery of limestone clearly caused consternation as evidenced in letters to the S&DR from

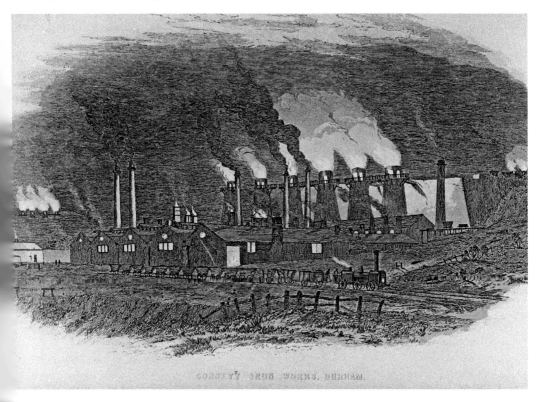

The Consett works of the Derwent Iron Company in 1861. (Beamish Museum)

the seemingly hot-tempered William Carrgill of the Derwent Iron Company, who placed such demands on the railway.[30]

As well as limestone finding a ready customer at Consett, the sale of lime increased too. This was owing to its increasing use in agriculture, as well as the S&DR having a much wider network than was available to the S&TR. A report to the S&DR Directors dated 15 March 1849 noted how in the four years since the S&DR took over the line, the chaldrons of lime sold went from 3,658 chaldrons in 1845 to 4,847 chaldrons in 1846, 8,950 chaldrons in 1847 and 9,023 chaldrons – carrying 29,324 tons – in 1848. Farmers said the demand was increasing 'on account of its quality and honesty'.[31] This was being sold not just along the S&DR but also along the York & North Berwick Railway, Middlesbrough & Redcar Railway and the Leeds & Thirsk Railway. The Leeds & Thirsk Railway had complained about 'exorbitant charges' made for delivery owing to the high rates charged by the York & North Berwick for transiting over their lines to reach the Leeds & Thirsk.

The kilns at Stanhope produced 7,970 chaldrons of lime using 3,239 chaldrons of coal, whereas the other S&DR kilns at Adelaide (presumably at the Adelaide colliery, near Bishop Auckland) and Bishopley, near Frosterley, on the Wear Valley Railway had produced 1,524 and 415 chaldrons worth of lime respectively.[32] Such was the demand and confidence that the Derwent Iron Company had contracted with the S&DR to be supplied by them with limestone until 1907. The limestone at Stanhope was in a seam an average of 20-feet thick, 27-feet thick at the deepest point. It was recommended that the kilns at Bishopley be used to continue to produce lime in order to preserve the limestone at Stanhope for sale to the Derwent Iron Company – aided by the fact that the York, Newcastle & Berwick Railway's wagons were too wide for Hog Hill tunnel on the Crawley incline so having them go straight to Bishopley on the Wear Valley line was much easier.[33]

On the week ending 28 July 1849, 1,516 wagons for the Derwent Iron Company travelled over the north part of the line (slightly down on 1,588 wagons the same week in 1848), as well as fifty-seven wagons of Stanhope lime (out of 250 ½ wagons full in total that had left the Stanhope limekilns that week), 262 wagons of S&DR limestone, twenty-six wagons of lead traffic and fifty-three wagons of sundry traffic. Over one month – July 1850 – 34,180 tons of minerals and 1,163 tons of goods were hauled by locomotive on the Parkhead level, with 28,830 tons of minerals and 579 tons of goods hauled on the Rowley level.[34]

Another demand on the S&DR was placed by the Derwent Iron Company tapping into the recently discovered rich resources of iron ore in Cleveland. The S&DR was eminently placed with the furthest extents of its network handily connecting the two, taking the iron ore the 54 miles directly to Consett, although owing to inclined planes on the western section it was not as straightforward as it could be.[35] In 1857 the iron ore mines at

30 TNA RAIL 716/11
31 TNA RAIL 667/621
32 TNA RAIL 667/622
33 TNA RAIL 667/621
34 TNA RAIL 667/730 Stockton and Darlington Railway (Derwent Branches) Contractors Haulage Account
35 Warren, K., *Consett Iron 1840 to 1980, A Study in Industrial Location* (Oxford: Clarendon Press, 1990) pp.19–20

Upleatham were sold from the Derwent Iron Co. to Pease & Partners – a company strongly associated with the S&DR.[36]

Excerpts from the records of the S&DR's Power & Haulage Committee provide an insight into the movement of limestone to Consett. On Monday 1 September 1856 it was recorded that the 'attention of this Committee has been directed to the deficiency in supply of Limestone to the Consett Company and after consideration the Secretary is requested to make an appointment to meet the Chairman of that Company, and ascertain the maximum quantity which they will receive daily and the Lime Contractor anticipate being able to arrange for the delivery of a large quantity regularly and hope to give them more definite information within 10 days'.[37] Two months later on 31 October, the committee recorded that 'The Contractors further submit that to accommodate wagons by day for the night shift, a siding to hold about 100 wagons will be required which should be near the Waskerley incline top. The Engineer is instructed to make this provision.'[38] Additionally:

> The Haulage Contractors reported upon the expediting of the traffic across the Hownes Gill and say that it can only be done by a double shift of men and this they are preparing to carry out, alleging that the night work can only be carried on by increased expense as compared with day work, the question as to any extra allowance to them if any, is referred to the Engineers[39]

The following year on 31 August 1857 it was reported that limestone consumption at Consett was for ninety wagons carrying 3 tons a day to supply the fifteen blast furnaces at work, with the ironworks wanting a delivery of 110 wagons a day until further notice.[40] The bottlenecks of Nanny Mayers incline (sometimes referred to as Waskerley incline or bank, the two terms being interchangeable) and Hownes Gill inclines were frequently barriers to keeping up a good supply of limestone to the ironworks, and were to result in another phase of improvements to the Wear & Derwent line by the S&DR.

36 Warren, K., *Consett Iron 1840 to 1980, A Study in Industrial Location* (Oxford: Clarendon Press, 1990) p. 28
37 TNA RAIL 667/59
38 TNA RAIL 667/59
39 TNA RAIL 667/59
40 TNA RAIL 667/59

Crossing the Gill

A letter to the S&DR on 13 September 1849 from William Cargill of the Derwent Iron Company mentioned how the produce of the ironworks for the south was mainly being moved by the Pontop & South Shields Railway, whereas if the problem of crossing Hownes Gill was satisfactorily resolved then 'it would go your way'. By 1853 a way was found to increase the number of wagons that could get across the gill: the cradles on the inclines were dispensed with and wagons were attached directly to the wire rope and ran up and down the gill three at a time, allowing 550 to 650 wagons a day to get across. Unsurprisingly given the steep gradient this sometimes resulted in wagons spilling their loads and was not a long-term solution. A notice was issued by Thomas Macnay, secretary of the S&DR, on 6 May 1853 directed at 'Railway contractors, bridge builders &c':

> The Stockton and Darlington Railway Company are prepared to receive DESIGNS (such designs to be accompanied by estimates) for a TIMBER ERECTION, equal to the carrying on of locomotive mineral traffic across the Gill, known as 'Hownes Gill', near Shotley Bridge, in the county of Durham[41]

Premiums ranging from £50 for the first approved plan, £30 for the second and £20 for the third were offered, and if any of the designers were contracted the premium would be included in the contract. The resulting design, approved in 1856, was that by Thomas Bouch, brother of the S&DR's chief engineer. Thomas Bouch is perhaps better known for his Tay Bridge, which disastrously failed in 1879 with many lives lost on a train that was crossing it, but his bridge at Hownes Gill stands to this day. It took a year and five months to build and was constructed of just over 2.5 million firebricks, as well as stone. Crossing the gill at a maximum height of 150 feet above it, the 730-foot-long structure comprised of twelve semicircular, tall arches with buttresses to support them from new, and low iron railings on either side of the viaduct. The four central arches were also inverted below ground at the suggestion of Robert Stephenson to counter the issue of soft ground at the

41 *Newcastle Courant*, 13 May 1853

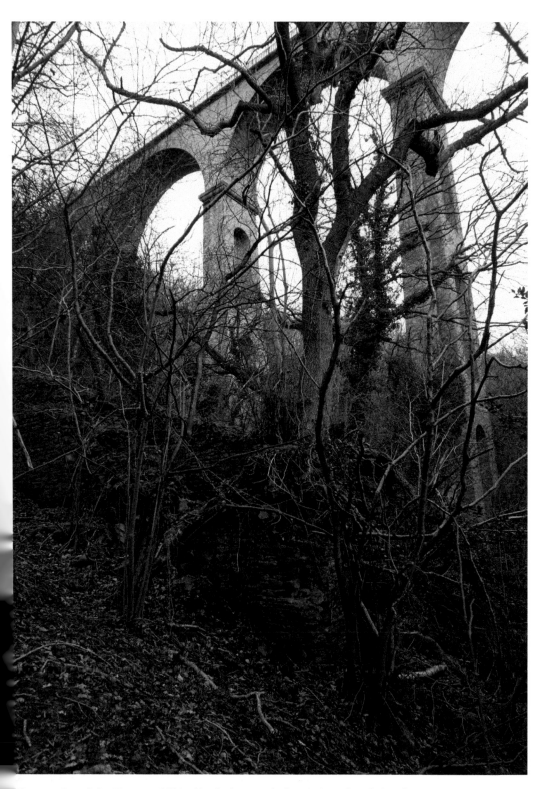

The remains of the Hownes Gill inclined plane with the 1858 viaduct behind.

foot of the gill. As the original engineer of the line, Robert Stephenson's involvement in the most impressive structure on its entire route, built some twenty-four years after the line opened, was appropriate. It was also to be one of the last of his countless contributions to railways as he died a year after the viaduct was opened.

The construction of the viaduct was noted for having been 'unattended by any accident' and opened in late June 1858.[42] Sadly since then it has acquired a reputation for local suicides, and a red cross painted on one of the piers is locally believed to refer to one death caused by a fall from it. The route to the viaduct takes a very slight deviation from the original alignment so the inclines could still work while construction took place, and a row of railway workers cottages on the Rowley side of the gill by the original alignment remained occupied for many years.

While work on the viaduct was ongoing, in late 1857 the Northumberland and Durham District Bank failed, which the Derwent Iron Company owed a substantial amount of money to. Numerous shareholders saved the ironworks from collapse, and the S&DR and NER supported it with £200,000. It is not surprising the railways wanted to protect it; by 1857 there were eighteen blast furnaces in operation, and together with other activities done by the works used 600,000 tons of coal, 300,000–400,000 tons of iron ore, 110,000 tons of limestone and produced over 150,000 tons of finished iron products a year – a colossal amount of traffic for the two railways.[43] Just as the ironworks depended on the railways to bring in the raw materials and take out the finished goods, so too did the railways in the area depend on the ironworks – particularly the Wear & Derwent line with the section from Crawleyside to Waskerley predominately engaged in moving limestone from Stanhope to Consett. Saved from closure, the Derwent Iron Company was reconstituted in 1864 as the Consett Iron Company.[44]

With the viaduct completed, work was underway to avoid Nanny Mayer's self-acting incline. The 2-mile-long Waskerley deviation was built to avoid Nanny Mayers incline, leaving the original route at Whitehall junction near the S&TR lime and coal depot, and climbing steeply to join the Waskerley Extension Railway south of Waskerley, from where trains could reverse to go up to Waskerley and along towards Crawleyside, or continue south. This was built as double track throughout. This was not ready until 1859 with its steep cuttings and high, lengthy embankments, and when open the steep Sunnyside engine-worked inclined plane between Tow Law and Crook on the Weardale Extension Railway remained another barrier to through working (the deviation to avoid it opened in 1867 to freight, 1868 to passengers). The junction of the Weardale Extension Railway and Waskerley deviation was named Burnhill Junction, with the deviation sometimes named Burnhill instead, although it was termed the Waskerley deviation at the time. The Wear & Derwent Railway had now reached its final form, and the rails on Nanny Mayers incline were lifted at the end of 1860.

42 *Newcastle Courant*, 2 July 1858

43 Tomlinson, W. W., *The North Eastern Railway, its Rise and Development* (Newcastle: Andrew Reid, 1914) pp. 562–3

44 Warren, K., *Consett Iron 1840 to 1980, A Study in Industrial Location* (Oxford: Clarendon Press, 1990) pp. 22–25

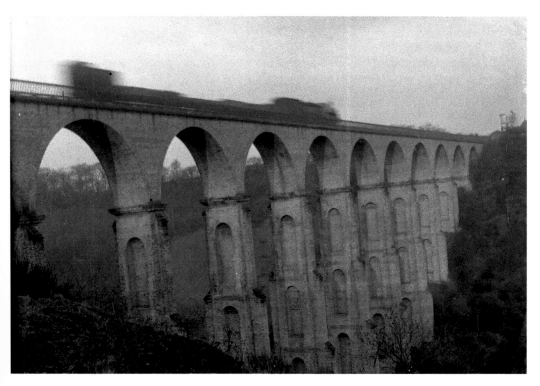

Oblique view of a goods train crossing Hownes Gill viaduct. (Beamish Museum)

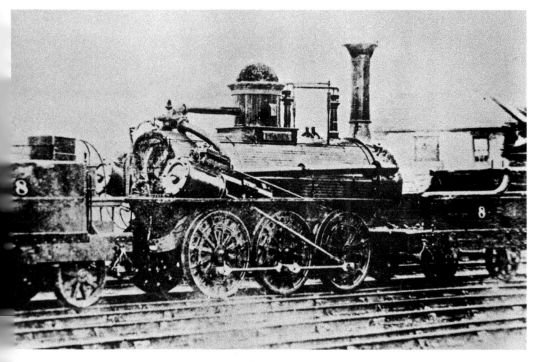

S&DR Tory class locomotive No. 8 *Leader*, which pulled the first train over Hownes Gill viaduct
n June 1858. (Beamish Museum)

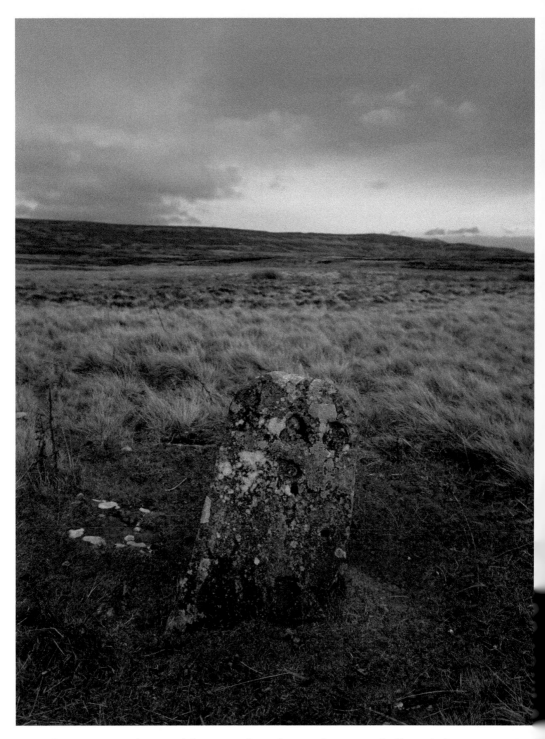

The S&DR erected many of these stone boundary markers instead of lineside fencing sometime around or after 1847, still visible in great numbers alongside the line and with examples preserved elsewhere. Some of those along the line are buried, some weathered thin, some toppled over and some almost completely exposed.

Two minor additions to the appearance of the lineside came from the S&DR during its ownership of the line. The most notable is the addition of stone boundary markers bearing S&DR (in various typefaces suggesting different stonemasons) on parts of the line where there is no boundary fence, denoting railway land. Certainly the sheep took no notice of this, and gates were installed – one by the north portal of Hog Hill tunnel (which curiously has two boundary markers against the top of the south portal), one at Parkhead station and one at Waskerley. Following a decision by the S&DR to mark residential properties that they owned, in 1857 ceramic plaques were affixed to S&DR owned houses, but only those that were intended for occupation – goods sheds, engine houses and the like would not receive them. Those on the line from Crawleyside had the prefix 'K'; for example K3 was the two cottages at Crawley engine (now converted to one dwelling), K4 the four houses at Weatherhill engine house (plaque still in situ) and the two rows of cottages at Waskerley were K10 (Low Row) and K11 (High Row). The stationmasters house at Rowley was L10, the L suffix also applying to houses on the route to Crook.[45]

45 Research notes of Jane Hackworth-Young

Passenger Service

Upon the S&DR's takeover of the western half of the S&TR, a passenger service was deemed feasible and services commenced on the line from 1 September 1845, with a carriage or carriages starting at Crawleyside as well as at the top of Hownes Gill, joining at Waskerley, then continuing to Crook. The journey would have included travelling up and down the inclined planes on the route. The winter timetable of 1845 from 31 October just went between Waskerley and Crook, but reopened to Crawleyside and Cold Rowley on 1 April 1846. A small station building at Cold Rowley was built in 1846 on the south side of the single track, and although Rowley was a small settlement, it was within walking distance for the larger village of Castleside, and until passenger services reached it, it would also be useful for travellers to and from the expanding industrial town of Consett. Later in 1846 the service to Crawleyside was discontinued – passengers for

1846 timetable for trains passing over the line to and from Crook. (Kind courtesy of Ian Dinmore (railarchive.org.uk))

WEAR & DERWENT JUNCTION RAILWAY.

On the 1st of APRIL, 1846,

Trains for the Conveyance of Passengers will commence running every Day (Sundays excepted) from COLD ROWLEY and CRAWLEY near Stanhope, to CROOK, in connection with Trains to and from Darlington, Stockton, York, &c.

TRAINS LEAVE	1st Trip. A.M.	2nd Trip. P.M.		TRAINS LEAVE	1st Trip. A.M.	2nd Trip. P.M.
Cold Rowley at	6·0	4·0		Crook - - at	8·50	5·30
Crawley near Stanhope	6·0			Waskerley Park	9·50	6·30
Waskerley Park	6·30	4·30		ARRIVE AT		
Crook - - -	7·30	5·30		Cold Rowley -	10·20	7·0
				Crawley, for Stanhope		7·0

J. READMAN, PRINTER, DARLINGTON.

Stanhope could travel to Frosterley by rail when the station opened there in August 1847 and onwards to Stanhope by horse bus.[46] Stanhope finally received its own station and railway when reached by the Wear Valley line in 1862, with a new station built when the line extended to Wearhead in 1895.

Two fascinating accounts of the early passenger services on the line exist. The following quote, based on the notes of guard Thomas Cheeseman and written by William Weaver Tomlinson in his *The North Eastern Railway; its rise and development* give an idea of the passenger conditions:

A trip by the Wear and Derwent branch of the Stockton and Darlington Railway over the elevated tract of moorland lying between Crook and Cold Rowley may have been attended with a certain amount of discomfort, but it was by no means lacking in railway interest. Two composite carriages, fitted up with outside hand brakes, sufficed for the passenger traffic between Crook and Cold Rowley. They were attached to a number of mineral wagons and drawn up Sunnyside incline (1¾ miles) by a stationary engine. From the top of the incline the mixed train was hauled by a locomotive engine at a speed limited to 15 miles an hour to Waskerley Park Junction, the line being a single one with one siding or passing-place on an average to every 1,500 yards. The carriages were then detached and let down Nanny Mayor's incline (¾ mile), running loose behind two or three loaded wagons. At the foot of the incline they were attached to a mineral train and drawn by a locomotive engine to Cold Rowley. For the return journey the regulations provided that not more than two wagons were to accompany the coaches in going up the Waskerley incline and that in descending the Sunnyside incline the coaches were to run loose behind the train. According to the statement of one of the old guards the practice was to brake the coaches down this incline, without using the rope, right through to the old station at Crook, which was near to Thistle Flat Colliery. There were no signals between Crook and Cold Rowley and no pointsmen. When it was necessary to enter a siding the fireman had to jump off the engine and attend to the switches. No van was provided for the guard, who not infrequently, at week-ends, when the carriages happened to be very full, rode outside on the buffer.[47]

Thomas Cheeseman passed away in 1897, having started his railway career on the Stanhope & Tyne working between Carr House and Annfield Plain in the early 1840s. He was made passenger guard in 1847 between Hownes Gill and Crook, the two composite carriages being described as having three compartments each with no brake compartment and luggage placed on top of the carriages. The footbrakes were on each corner and frequently taken down the inclines by Mr Cheeseman without use of the rope. He was later presented with one of his old carriages (described in 1897 as 'queer old structures that to-day would only be laughed at'), still standing in his garden at the front of Deerness House, Tow Law, at the time of Cheeseman's death. However, it is not known what became of it in the

46 Hoole, K., *A Regional History of the Railways of Great Britain Volume 4: The North East* (Newton Abbot: David & Charles, 1965 (1978)) p. 177

47 Tomlinson, W.W., *The North Eastern Railway, its Rise and Development* (Newcastle: Andrew Reid, 1914) pp. 529–30

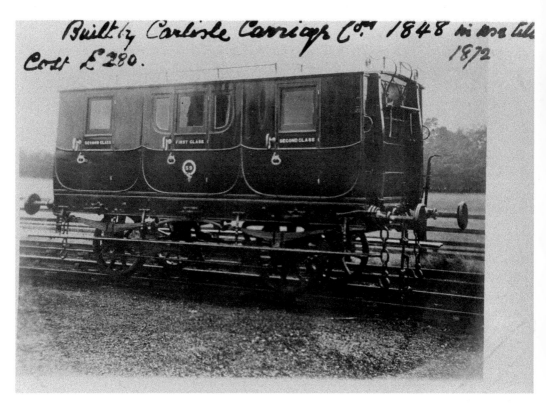

Built by Carlisle Carriage Co. 1848 in use till 1872 Cost £280.

Typical 1840s three-compartment composite carriage of the S&DR. (Beamish Museum)

years since. In 1852 he was made traffic superintendent between Crook, Consett and the limekilns at Crawleyside, holding the position until retirement in 1894.[48]

The second account of passenger traffic on the line mentions the passenger service commencing from the top of Hownes Gill incline (believed to have extended back to Hownes Gill from Cold Rowley in January 1857), then going on to Rowley. After Hownes Gill viaduct opened in 1858 the passenger service continued to a station at Carr House some distance east of the Carr House engine and close to the site of the later 1896 Leadgate station[49]:

> I recollect myself coming down the Gill – there was no viaduct then – coming down about 300 steps and up another 360 steps, and then the guard shouting 'come on'... the train took you to Rowley. You got out there at a little wooden station ... one half was for the Station Master, Mr Petty, and the other half was for anyone else, if you could sit down without grease. You were then taken to Nanny Meyer's at bank foot by the train, and there was a public house there, and they did not object to your getting off to go in and get a drink the time they were putting the couplings on the carriages. You then got to Waskerley, up the hill, and from there to Sunniside – and then down the bank again.[50]

48 *Northern Echo,* 1 September 1897
49 Railways of Consett and NW Durham, p. 64
50 *Consett Chronicle,* Report on presentations to Mr Richardson, Station Master at Rowley, on his retirement, July 1905

The Cold Rowley stationmaster, John Petty, had joined the S&DR in 1851 at the age of just fourteen – his first job was to sit on the front carriage of trains running between Crook and Sunnyside and pour sand onto the rails. He was made stationmaster at Cold Rowley aged seventeen, relocating to Newbiggin in Westmorland in 1861.[51] The quote came from a Mr Scott, who mentioned that a Mr Muse 'on coming into the room mentioned a wooden-legged station master' of whom details are not known, and the 'little wooden station' describes Cold Rowley station's appearance after the 1853 decision by the S&DR Works Committee to enlarge the existing station at Cold Rowley, which was described as a 'room' at the expense of £25.

The opening of the Waskerley deviation meant there was no sense in passenger trains going up to Waskerley from Burnhill junction and back again, so a new passenger station was built at Burnhill, opening on 4 July 1859. There was no road access, a mile-long footpath joining it to Waskerley, which remained as a goods station. The original facilities at Burnhill were not up to much, as in late 1892 petitions were sent to the general manager and directors of the NER complaining about the passenger accommodation provided at Burnhill. General Manager George Gibb 'replied that he would have the complaints looked into'.[52] Certainly by the time it closed it had enclosed waiting areas on both platforms and full height platforms. The opening of the Waskerley deviation and its avoidance of Nanny Mayers incline was hailed by the *Durham Chronicle* as meaning 'passengers will not have the fear of broken ropes or necks constantly before their eyes, the incline being altogether avoided'.[53]

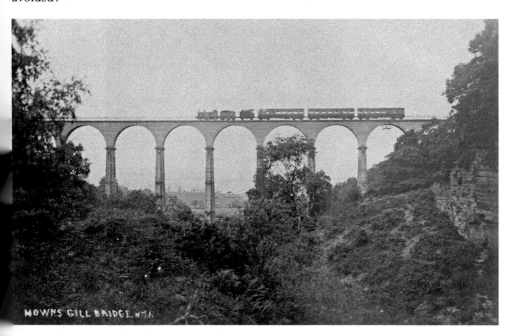

HOWNS GILL BRIDGE. N 1.

Passenger train crossing Hownes Gill.

51 *Newcastle Evening Chronicle*, 3 October 1906
52 *Newcastle Daily Chronicle*, 24 December 1892
53 *Durham Chronicle*, 22 January 1858

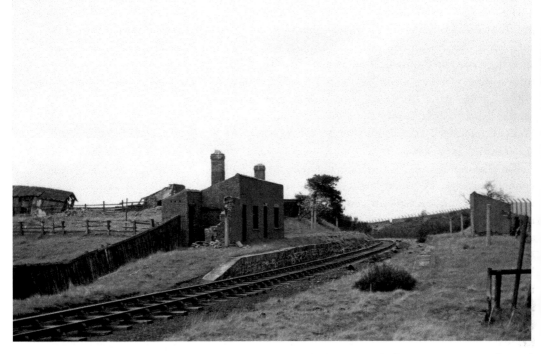

Burnhill station after closure showing the derelict buildings and platforms. (Peter Eggleston/ North Eastern Railway Association)

Although Nanny Mayers incline was avoided, passengers heading south still had to contend with the Sunnyside incline between Tow Law and Crook, which was eventually avoided in 1868 for passenger services allowing through working throughout from Consett to Crook and onwards to Bishop Auckland and Darlington. The station at Carr House was closed when a link was made to the Lanchester Valley line at Hownes Gill and from 1 October 1868 passenger trains went to Benfieldside. The Carr House stationmaster, Samuel Leybourne, then became stationmaster at Benfieldside[54], the station changing name to Blackhill from 1896 after intermediately being known as Consett from 1882 and Consett & Blackhill from 1885.[55] This new station, on the north-west side of Consett, was part of the 1867 Derwent Valley line, which came down from Newcastle via Swalwell, Rowlands Gill, Lintz Green and Shotley Bridge. It also joined the 1862 Lanchester Valley line, which came up from Durham via Lanchester and Knitsley, and originally had its terminus south of the iron works at a station named Consett which closed when Benfieldside opened.

Benfieldside station became the hub for passenger services in the area. Passengers who arrived there from the Wear & Derwent line, which brought them from Darlington via Bishop Auckland, Tow Law, and the stations on the line at Burnhill and Rowley, were able to change for trains towards Durham via Lanchester or up towards Newcastle via Rowlands Gill. Nearly thirty years later, when the route of the Stanhope & Tyne's eastern section was

54 *Hartlepool Northern Daily Mail*, 27 February 1888

55 Whittle, G., *The Railways of Consett and North-West Durham* (Newton Abbot: David & Charles, 1971) p. 65

deviated avoiding all remaining inclined planes, a new Consett station was built in 1896 on the former Wear & Derwent line near the site of the Carr House engine house. Passenger services on it ran from Blackhill via Consett station to Leadgate, Annfield Plain, Shield Row (Stanley) and Pelton, joining the East Coast Main Line heading towards Newcastle at Birtley.

Rowley had 'Cold' dropped from its title in 1868, and this is often erroneously given as the date of construction for the station building since preserved at Beamish, but this came five years later. Following the doubling of the track between Rowley and Hownes Gill, in October 1872 the Darlington Section Works Committee of the NER (the 'Darlington Section' was the remains of the S&DR's control over its area despite having been amalgamated with the NER almost a decade before) decided that the goods depot and loading bank needed to be moved to an adjoining site, and following this in February 1873 the section's architect William Peachey was asked to prepare a plan for a 'very small station' at Rowley – still described as Cold Rowley despite the official title change.[56] Peachey's plans were approved in March, and a contract signed with William Ridley of Tow Law in May, a surviving plan by Peachey being dated 30 June 1873 and the station likely completed that year.

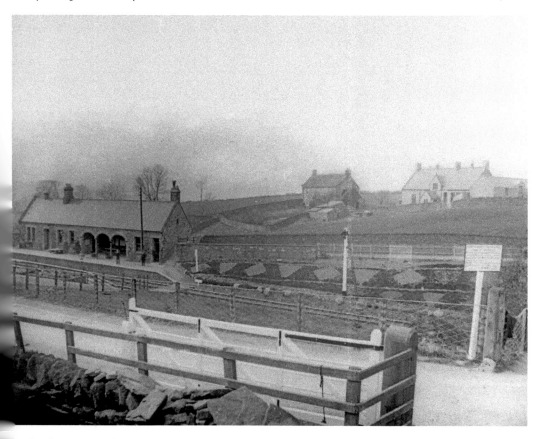

Early photo of Rowley station. (Beamish Museum)

56 TNA RAIL 667/93

By the time Rowley station was built, passenger services would be provided by rakes of four- or six-wheel carriages, steadily replaced by longer bogie carriages in the early twentieth century, a far cry from the original passenger services on the route that consisted of small four-wheeled carriages that more resembled the horse-drawn, road-going stagecoaches of the day, and which suffered the ignominy of being coupled on to mineral trains. However, like their predecessors, these later carriages still consisted of separate compartments with no corridor to move along the carriage and no toilets. The bogie carriages, offering a smoother ride with the wheels on two separate, sprung, four-wheel bogies, had another distinction from their four- and six-wheeled predecessors – a clerestory roof. A clerestory ('clere-story') had a raised centre with glass windows, allowing more natural light into the compartment than that allowed just from the door and side windows. Elliptical roof carriages started to be introduced by the NER in the Edwardian era and also appeared on the line. Although the line closed to passengers before their introduction, those on enthusiast railtours who visited the line in its final years travelled in steel bodied Mk 1 carriages and diesel multiple units.

The passenger services on the line continued as a typical rural service with just a few trains a day in each direction, with the stations at Rowley and Burnhill never being especially busy, but vital for serving the needs of the local area – especially at Rowley with the goods services and coal depot. Although passenger traffic on the line was minor compared to goods, it is owing to the passenger service serving the community so importantly that Rowley station became a topic of interest for local photographer and cartoonist William Bainbridge of Castleside. Thanks to him – and his photographs being saved – a wonderful photographic record of Rowley station survives.

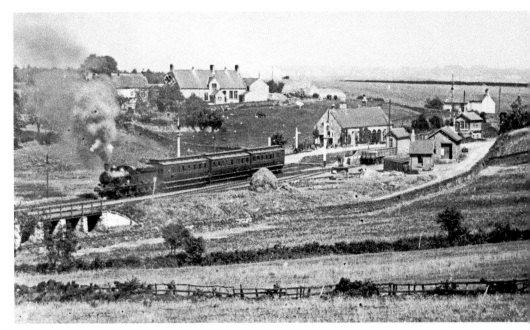

Overall view of Rowley station from 1914 or later with a passenger train of three clerestory bogie carriages pulled by a 2-4-0 locomotive. On the left is the coal depot for selling coal to the local community, a profitable side business for the stationmaster. (Beamish Museum)

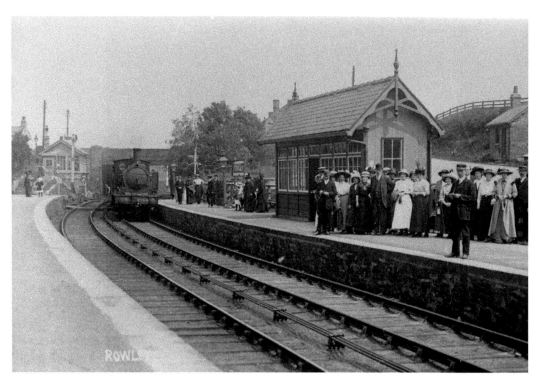

C class locomotive No. 1564 entering Rowley from Blackhill. This image gives a good view of the waiting shelter on the south platform, and to the right the road down to the goods yard and coal drops can be seen. (Beamish Museum)

Locomotives

The S&DR's locomotive fleet mainly developed around the haulage of coal and other minerals, which was the main traffic on the line. When the S&DR reached Waskerley, the mainstay of its fleet was six-coupled large boiler locomotives with return flues (where the fire tube door is at the same end as the chimney, with the hot gasses from the fire moving almost the entire length of the boiler twice via the 'return flue' before going up the chimney, instead of at separate ends as on conventional looking locomotives). The first of this design on the S&DR was Timothy Hackworth's No. 5 *Royal George* of 1827, built using the boiler shell of Robert Wilsons' *Chittapratt*, which also gifted the S&DR the design for the sturdy two-piece cast-iron 'plug' wheel design subsequently adopted by, and commonly attributed to, Timothy Hackworth. A growing number of these locomotives by 1845 had single flue return multitube boilers rather than a single return flue. The fire, in a firetube set into the centre of the boiler, continued in a single wide diameter tube for the gasses to move down the length of the boiler with a large chamber at the rear of the boiler, then the gasses returned back in dozens of smaller tubes, known as multitubes, the smaller tubes and greater number of them giving an increased heating area and better steaming.

On single return flue locomotives the firetube door and chimney were side by side, but on the single flue return multitube boilers with the firetube in the centre of the boiler, the multitubes ended around the top and sides of the firetube in a distinctive looking upturned horseshoe-shape smokebox which straddled the firetube door and with a chimney centrally located on top. The return flue boiler and the improved single flue return multitube boiler was technologically a dead end, but for the circumstances of early railways where the need was simply for powerful, simple locomotives to move long, heavy trains of coal or other minerals where speed did not matter, they were perfectly suited, and this remained the case on the S&DR for many years. Such locomotives were perfect for the conditions of the Wear & Derwent line too. To add to their unusual appearance to modern eyes, the S&DR 'mineral' (to differentiate between smaller, faster 'passenger' locomotives) locomotives were fitted with two tenders – one at the front that carried the coal, as the fireman was at the front where the firetube door was, and one at the rear for the water. Brakes on early locomotives were either very basic, or in some

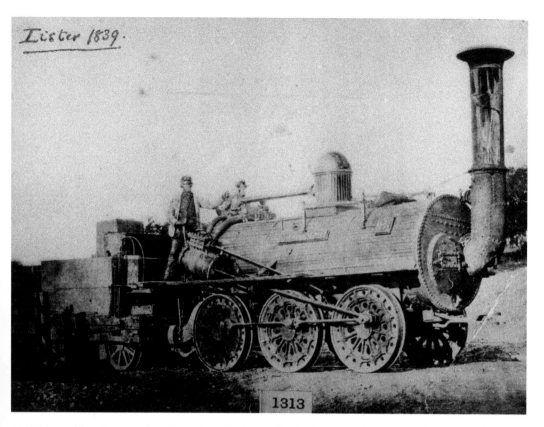

Lister 1839.

1313

S&DR Tory class locomotive No. 9 *Middlesbro* with the front tender removed showing the single-return flue arrangement, with the firetube door next to the chimney. (Beamish Museum)

cases non-existent – it was noted by the S&DR in December 1845 that a minute had been received from the Wear & Derwent Committee 'wishing for brakes on the tenders of all the Engines on that line; report is made that they are in hand'.[57] Usually the crew would walk or climb along a train of wagons being pulled by the locomotive, pinning the brakes down as required.

The unusual and outdated appearance of these double-tender locomotives, with their return flues and no frames, resulted in Francis Whishaw describing the S&DR's fleet in Autumn 1839 as mostly comprised of 'rough six-wheel coupled engines'.[58] By 1845 the most common class was the Tory class, introduced in 1838 and built by several builders including Hackworths of Shildon who had designed them. They were an improvement on previous types and had inclined cylinders for driving the wheels, and although the first, *Tory*, was built with a single flue return multitube boiler, not all of its classmates were, others being built with a single return flue and later modified. Two Tory class locomotives were based at Waskerley in 1847, No. 9 *Middlesbro* and No 10 *Auckland*, as were four of

57 TNA RAIL 667/111 Shildon Works Minute Book

58 Whishaw, F., *The Railways of Great Britain and Ireland practically described and illustrated* (London: John Weale, 1842) p. 419

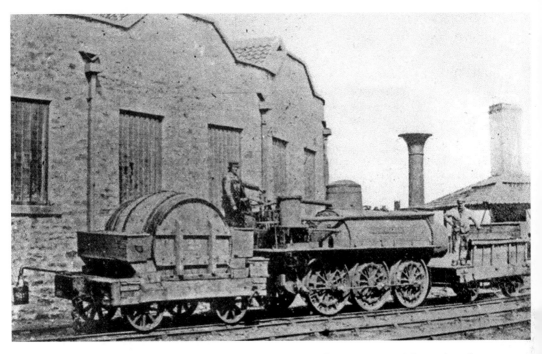

Stockton & Darlington Railway locomotive No. 23 *Wilberforce*, one of the earliest locomotives known to work the line. Seen outside the roundhouse engine shed at Shildon. (Beamish Museum)

the older Director class locomotives, which had a shorter boiler and vertical cylinders, No. 19 *Darlington*, No. 20 *Adelaide*, No. 21 *Earl Grey* and No. 23 *Wilberforce*.[59]

To work traffic between Nanny Mayer's incline and Hownes Gill inclines, an engine shed at the foot of Nanny Mayer's incline named Cold Rowley was suggested in May 1845 – it was approved on 20 August, and by 2 September new track had been laid into the shed. The suggestion in Bouch's report that 'a light locomotive might be used here to advantage' seems to have been adhered to with the allocation here of No. 28 *Conside*. *Conside* was unusual compared to most S&DR locomotives at that time as it looked like a conventional locomotive! Built by Richardson of Hartlepool and purchased by the S&DR second hand from the West Hartlepool Iron Company, *Conside* had a smaller multitube boiler, conventional firebox and smokebox at opposite ends and a running board the length of the locomotive with proper frames. *Conside*'s allocation to Cold Rowley is known through its involvement in an accident in February 1847:

> On Saturday the 27th as Geo Greener a platelayer was attempting to get upon the fore part of a truck, the last of a train of wagons, propelled by the 'Conside' Engine at a slow pace, near Cold Rowley Station, he fell in front of the wheels, which passed over and crushed his thigh bone. Surgical attendance was immediately procured & the limb amputated, but he expired in a few hours.

59 Fleming, J. M. 'Waskerley Junction and Nanny Mayor's Incline' in the *North Eastern Express* No 91, May 1983

The remains of Cold Rowley engine shed and the adjacent cottages. (Ken Hoole Collection – Head of Steam – Darlington Railway Museum)

An inquest was held on 1 March 1847 before the coroner and no blame was attached to anyone and a verdict of accidental death was returned. He left a widow and two young children.[60]

The locomotive shed at Cold Rowley had room for two locomotives but only ever seems to have been allocated one, presumably sufficient for the traffic which was limited by the capacity of the inclines at either end of the section it worked. There were also four adjoining cottages which may have pre-dated the shed and been used for workers operating it when it was a horse-worked section. Despite the name of Cold Rowley it was some distance from the settlement – and passenger station – of that name, and the shed name differs in S&DR records to Cold Rowley Level (reflecting the use of the word 'level' to describe a flat, or relatively flat, section of line between inclined planes), Cold Rowley Flats and Waskerley Healey Field, as well as the usual Cold Rowley.

In July 1847, No. 23 *Wilberforce*, built in 1833 by Hawthorns of Newcastle, was pushing a train of wagons on the Weardale Extension Railway with John Dixon as driver, apparently being driven backwards against the wagons, with the water tender nearest the wagons. As the train was running past High Stoop the centre bar between the water tender and the engine broke, crushing Dixon's leg between the water barrel on the tender and the locomotive. Although the accident was not on the Wear & Derwent, Dixon was conveyed to Cold Rowley where the limb was set and later reported to be 'doing as well as may be looked for'.[61]

60 TNA RAIL 716/11 Correspondence re. working of lead and lime traffics
61 TNA RAIL 716/11

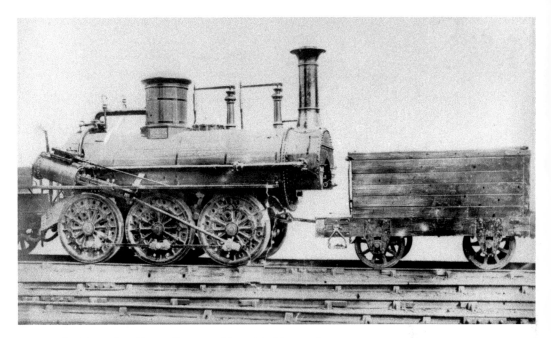

S&DR Tory class No. 25 *Derwent*. (Beamish Museum)

On 20 March 1854 it was noted that there were seven engines at Waskerley, but room in the shed for just four, so it was ordered to build another shed with room for four more locomotives. Cold Rowley was noted as having one locomotive there but room for two, and it was also ordered to build a shed at Carr House for a single locomotive, there already being one based there.[62] This was potentially Tory class locomotive No. 25 *Derwent*, which was 'known to have been employed between Hownes Gill and Carr House in 1852, and was also in the neighbourhood of the viaduct subsequent to 1858.'[63] In June 1855 a shed was still required at Carr House, the want for this being described as 'most urgent'. At a meeting in February 1856 the building of a shed for three engines at Carr House was ordered to be easily convertible to cottages at a future point.[64] An update on the shed was received in October 1856: 'erection was postponed until the coal was worked underneath'. The decision was later made to convert the boiler house of the stationary engine instead but no more seems to be recorded regarding it.[65] It is possible that it was not built at all owing to the construction of Hownes Gill viaduct and the Waskerley deviation meaning it was simpler to base all locomotives at Waskerley.

In 1856, thirteen locomotives are noted as being based at Waskerley, although this likely includes any sub-shedded at Cold Rowley and Carr House. Twelve of them were of the Tory class: No. 4 *Stockton*, No. 5 *Hope Town*, No. 6 *Dispatch*, No. 8 *Leader*, No. 18 *Auckland*, No. 13 *Ocean*, No. 15 *Tory*, No. 16 *Stanhope*, No. 22 *Alert*, No. 24 *Skelton*, No. 25 *Derwent* and No. 26 *Pilot* with a single Miner class, No. 31 *Redcar*.[66]

62 TNA RAIL 667/42

63 *The Locomotive Magazine and Railway Carriage and Wagon Review*, No. 272, April 1915

64 TNA RAIL 667/59

65 Hoole, K., *North Eastern Locomotive Sheds* (Newton Abbot: David & Charles, 1972) p. 218

66 TNA RAIL 667/779 A List of the Locomotive Engines on the Stockton & Darlington Railway

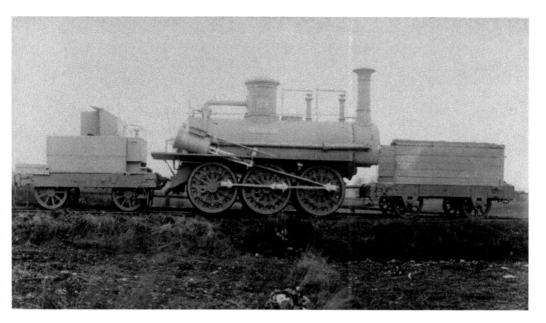

Derwent seen after it was presented to the NER in 1898 and restored at Darlington North Road Works before being placed on a pedestal at Darlington Bank Top station alongside S&DR No. 1 *Locomotion* of 1825. (Beamish Museum)

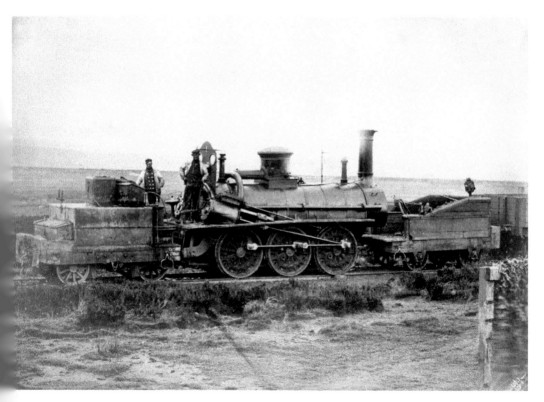

Unknown Tory class locomotive on or near the line, possibly during reservoir construction work. (Kind courtesy of James Waterman, not to be reused)

Ten of the Tory class and the single Miner were described as having a 'Napier' firebox, which seems to refer to the single firetube with return multitube boiler as still seen on *Derwent* today. No. 22 *Alert* had no mention of its firetube so likely had the old style of single flue, and *Alert* was included in a list of 'S&D engines that have done no work and little work in 1856' noted as 'working @ Waskerley in Good Order' and had run 6,116 miles in that year.[67] No. 22 *Alert* had been built by Kitchings of Darlington without having been ordered by the S&DR, offered to them in November 1847 for delivery in January 1848 for the cost of £1,400. The S&DR accepted with it 'considered an exception to the practice recently commenced of making or purchasing only coke-burning engines' – possibly it had been built for another customer and the sale fell through, or Kitching's just built it in the hope the S&DR would buy it![68] No. 4 *Stockton* was described as having a Fossick firebox ,which was a patent coke-burning firetube it was fitted with following a rebuild in 1851. It looked quite unlike the other Tory class locomotives, with the firetube at the rear with multitubes leading to a conventional smokebox at the front, and with front-mounted cylinders driving the rearmost axle.

No. 31 *Redcar*, the sole Miner class, represented the end of the double-tender Hackworth-style mineral locomotives used on the S&DR. It was similar to the Tory class but larger and with front-mounted cylinders. By the time of this survey, the more conventional 'Long Boiler' design introduced by William Bouch in 1847 was being built in greater numbers, although the older double-tender types would continue in service for over a decade longer.

North Eastern Railway 'Long Boiler' 1001 class locomotive at Waskerley engine shed below the coal drops for coaling the locomotives (there was another set of coal drops at Waskerley for the coal depot for landsale). (Beamish Museum)

67 TNA RAIL 667/728 Engines doing little or no work
68 KH 326 Stockton & Darlington Railway Locomotives, Ken Hoole

In a foretaste of the innovative use in recent years of engine sheds and other railway buildings as event venues, in August 1859 the Shildon Works Teetotal Band held their third annual concert at Waskerley 'in the house of the Fire-horse' with a crowd of around 700 being brought in from Berry Edge, Stanhope, Tow Law and elsewhere by special trains. The engine shed was 'fully decorated with the products of the moor; where nature was scant in her gifts, the deficiency supplied by artificials, flags of various devices, &c.Dependent lamps reminded the spectator of those wonderful fairy scenes so often read about in youth'. Readers who enjoy a drink or two at a concert today will no doubt be in awe that the teetotal bands performances 'on this occasion proved very satisfactorily that it needs not the stimulating cup to enable any to appreciate and execute first-class music'! Some attendants took part in athletic games, or rambled across the moor, apparently regretting they were a day too soon to legally have a shot at the many birds in the area.[69] One wonders if any took the opportunity to walk down Nanny Mayer's incline to the Railway Inn.

The completion of Hownes Gill viaduct and the Burnhill deviation saw the locomotive fleet in the area focus at Waskerley with Cold Rowley shed closing – and presumably Carr House also – and in the following decade the distinctive Tory class locomotives were replaced and sold off. The typical six-coupled goods locomotives of the S&DR and later NER would have replaced them, and in the early twentieth century there were numerous examples of the 398 Class and 'Long Boiler' 1001 Class 0-6-0 tender engines allocated to Waskerley. These in turn were replaced in the by the '59' (J22 in London & North Eastern

Splendid image of North Eastern Railway P2 Class (later J26) No. 406 at Rowley with driver, fireman and presumably guard of a goods train. (Beamish Museum)

69 *Durham Chronicle*, 19 August 1859

Railway classification), C (J21) and P (J24) class o-6-o tender engines and then by Wilson Worsdell's B class (later N8) o-6-2T locomotives, tank locomotive versions of the C class and ideal for the short distance mineral workings from the head of Weatherhill incline to Consett or any of the other sources of traffic on the line.[70] In 1914 Waskerley had eight locomotives and forty-one staff, the figure including six staff for Weatherhill incline and five at Crawley. Consett engine shed, built in 1875 to house two engines to work trains to Crook (not on the route of the Wear & Derwent but close to the iron works), was a sub-shed of Waskerley with five engines and fourteen staff.[71]

As part of the wider S&DR and then NER network other locomotives on through workings would also have been seen. A survey of locomotives on the NER on 31 December 1920 gives an interesting snapshot of those stabled at Waskerley at this time. There were twelve locomotives at Waskerley in total, two of the McDonnell '59' class o-6-os, Nos 455 and 498, four of the Fletcher '398' class o-6-os Nos 460, 1090, 1383 and 1454, five of the B Class o-6-2Ts Nos 238, 345, 349, 350 and 1105, and a single F Class 4-4-0, No. 663 for passenger work.[72]

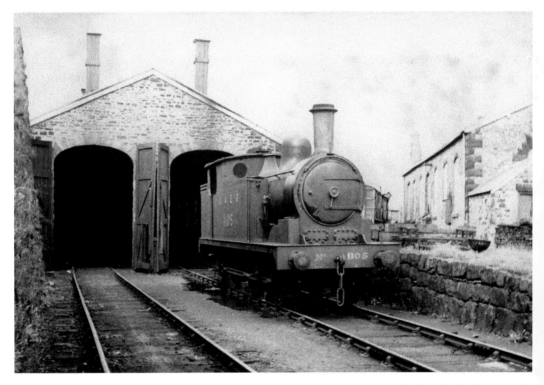

North Eastern Railway B class (LNER N8) o-6-2T No. 1105 at Waskerley shed. (Ken Hoole Collection – Head of Steam – Darlington Railway Museum)

70 Rounthwaite, T. E., *The Railways of Weardale* (Railway Correspondence and Travel Society, 1965) p. 21

71 Addyman, J. F., *North Eastern Railway Engine Sheds* (Cramlington: North Eastern Railway Association, 2020) p. 52

72 *Ken Hoole's Locomotive Stock of the North Eastern Railway as at 31st December 1920* (Manchester: North Eastern Railway Association, 1998)

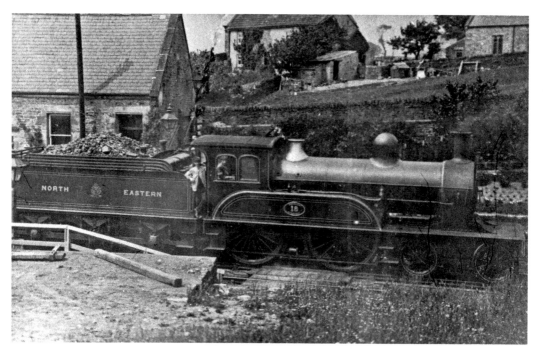

Above: North Eastern Railway F class 4-4-0 No. 18, built in June 1887, seen heading to Blackhill at Rowley. (Beamish Museum)

Left: A far cry from Stockton & Darlington Railway double-tender locomotives – an English Electric 350 hp diesel (Class 08) D3875 seen at Waskerley coming down from Meeting Slacks on 14 February 1967. (Beamish Museum)

Two snowploughs and a small breakdown train including a hand-worked crane were also based at Waskerley. Waskerley shed closed in 1940 after the LNER's decision to concentrate locomotives in the area at Consett, the shed being extended and remained in use until 1965. In later years the powerful Q6 eight coupled locomotives were seen on the line working the remaining traffic, and specially run enthusiast excursions to the line saw unusual types such as a K1 2-6-0 and a 'Derby Lightweight' diesel multiple unit. Other modern traction seen on the line in its final years were the English Electric 350 hp Diesel Electric (Class 08) and Type 3 Diesel Electric (Class 37) locomotives, which must have made a very strange sight in such historic, bleak and exposed surroundings.

Later Nineteenth Century

The Lanchester Valley line, a direct route from Consett to Durham, was built by the NER in the early 1860s, passing under the Wear & Derwent line to the north-east of Hownes Gill viaduct. As its tunnel under the Wear & Derwent line was under construction, beams of timber were in place on the cutting to support the railway above. On the morning of 13 January 1861 one of the beams gave way as a large engine with a train of mineral wagons was crossing over it on the Wear & Derwent line. The engine was tilted to one side but the crew took it over safely, and the passenger train that was due was given suitable warning, the passengers getting out and walking over the 'dangerous bridge', made safe a few hours later.[73] Another curious by-note of railway history occurred along the line with an unusual pastime for at least one man in the Consett area reported in early November 1867:

> A man, with a white sheet over him, was seen at Howne's Gill, about a month ago. Artificial ghosts have also been seen at Leadgate and Blackhill, seriously frightening several persons. On Tuesday evening a man, with a white sheet over him, was seen on the Stockton and Darlington Railway, where it crosses Knitsley Lane.[74]

The S&DR was absorbed into the NER in 1863, bringing the two halves of the S&TR back under common ownership for the first time since the original S&TR was dissolved in 1841. The takeover took some time, however – the S&DR retained its status for ten years according to the terms of the takeover, and even then clear S&DR individuality remained for some time after under the 'Darlington Section' of the NER. Although the trackwork up to Hownes Gill itself was limited to single owing to a narrow embankment and original bridge over the farm road to Knitsley, the line from Hownes Gill to Rowley was doubled about ten years after the viaduct was completed. There was a set of points on the Consett side of the gill, the two tracks being interlaced over the viaduct then spreading out on the Rowley side of the gill as properly separated lines.

73 *Newcastle Guardian and Tyne Mercury*, 18 January 1862
74 *Newcastle Guardian and Tyne Mercury*, 2 November 1867

On a dark evening at around 7 p.m. in November 1866 a particularly sad accident occurred resulting in the death of a young girl. Fifteen-year-old Elizabeth English, in the service of Miss Fowler at Whitehall Farm near Rowley, was taking a cow from the farm to a field, and en route had to cross the railway some three quarters of a mile from Rowley. What Elizabeth did not know was that further up the line towards Waskerley, the rearmost wagon from a train of stone being hauled by locomotive No. 110 (A 'Peel' class 0-6-0 named 'Hawk' built in 1856 by Hawthorn of Newcastle) which had passed shortly before had somehow come detached and headed back down the track at considerable speed. It struck Elizabeth, 'caught by the wagon, knocked down between the rails, her boots torn from her feet, and she was killed on the spot'. A few yards further on the wagon hit the cow with the result it had been 'almost disembowelled'. The speed at which the wagon was travelling can be gauged by the fact it was found the following morning still on the rails at Hownes Gill. A man close by heard the noise and raised the alarm and carried Elizabeth's body to the farm. On returning to the scene, the cow had got up, walked a few yards and then dropped dead.

The inquest heard from William Dikson, driver of No 110:

I had four wagons laden with stone from Cold Rowley depot to take to Waskerley. There is an incline on the line at Whitehall. The gradient is 1 in 40, consequently it is very steep. My full load is about fourteen wagons. The hindmost wagon got adrift; but I cannot exactly say where. I missed it when we got to the top of the bank, and found it at Howns Gill. I cannot account for it getting loose. There was nothing broken, the pin had simply come out of the shackle. I examined the coupling of the wagons before starting, and could not discern anything the matter either then or since. The pin of the wagon that broke loose was down to the shoulder, and I am satisfied that it appeared right when I left. We are the last engine, and have no guard. It was a dark night.

Dikson's statement was corroborated by the fireman, Joseph Thompson, 'adding that there was no extra shaking that night'. The locomotive inspector at Waskerley, Thomas Baty, vouched for the crew and stated that it broke loose owing to the pin springing out but could not give a reason for why it would do so. A verdict of accidental death was reached.[75]

Owing to the great need for limestone at Consett, Lanehead quarry started to be exhausted, and further quarrying began at Ashes to the east of Lanehead. A half-mile-long line was built to join the two quarries, which went under the Crawleyside road (the bridge is now filled in but the trackbed still very much visible) with an engine shed to the east of the road now converted into a private residential property. The Crawley incline was rebuilt to serve Ashes, the junction between the two being around 170 yards south of Hog Hill tunnel and continuing to the quarry with a bridge under the road whereas the original route – which also stayed in use – continued to curve to the west to the limekilns. A daily account of time waiting at Ashes bank foot for loading trucks in 1885 records three stoppages on 8 December totalling three hours and eight minutes – the longest being for two hours and forty-five minutes – owing to the cylinder covers of the engine working at

75 *Newcastle Guardian and Tyne Mercury*, 10 November 1866

Contrasts in transport: a horse-drawn cart belonging to W. Smith of East Butsfield being driven by Mr Armstrong and a Mann steam lorry being driven by Joe Marsh both delivering stone to Rowley. This was an important traffic: in 1906 13,434 tons of ganister – a stone used for furnace lining – was handled at Rowley station. (Beamish Museum)

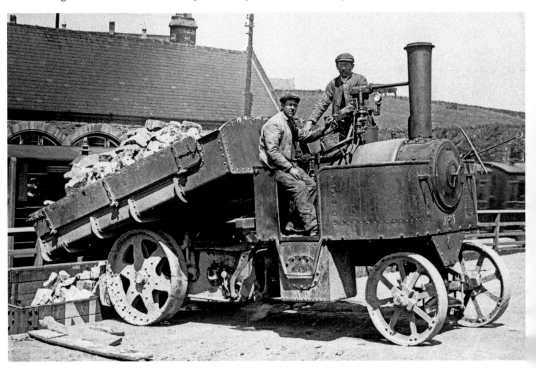

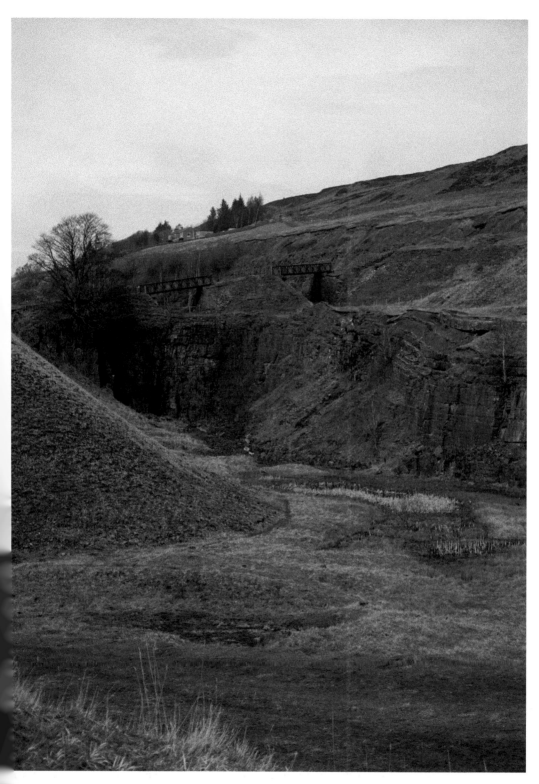

Ashes quarry, a mile long gouge in the landscape above Stanhope.

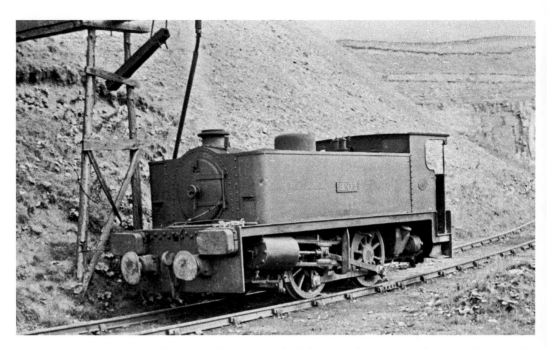

Consett Iron Company's B No. 3 locomotive, built by Hawthorn Leslie of Newcastle as Works No. 3495 in 1920 seen at Ashes Quarry. As the quarry stretched eastwards, a tunnel was constructed to join it to the older western half and eventually to the bank foot of the revised Crawleyside incline. The locomotive was supplied in specially lowered condition to fit through the tunnel. At least five Consett B class locomotives are known to have worked at Ashes. (Beamish Museum)

Ashes quarry being blown out. Getting locomotives up and down the inclines to work the quarries must have presented interesting challenges. Traffic also came up the incline from the lead and ironstone mine at Stanhope Burn owned by the London Lead Company, which also owned a nearby smelting mill, both connected by standard gauge line a mile and a half along to the foot of Crawley incline. The line was removed after it was taken over by a new company in 1866 but a 2-foot 6-inch narrow gauge line was later laid on the trackbed to exchange sidings at the Crawleyside limekilns. Ashes Quarry was sold to the Consett Iron Company in October 1900, an unknown locomotive on site being declared unsafe and swiftly replaced by one of the ironworks' own fleet sent from Consett.[76]

While not intended to be a complete survey of all the lineside customers of the railway, the reservoirs around Waskerley are worth mention as they came to change the appearance of the area as much as the railway did. Waskerley reservoir, to the south of the line, was built from 1868 to 1872, and Smiddy Shaw from 1869 to 1877, with S&DR's William Bouch being the engineer for its construction. Two ex-Stockton & Darlington Railway locomotives, No. 25 *Derwent* and No. 26 *Pilot*, which had both been based at Waskerley in their working lives, were used in the construction of Smiddy Shaw.

A siding at 'Black Cabin' between Parkhead and Waskerley attributed to the Weardale & Shildon Water Company existed in 1894, and the road from the site which today runs

76 Mountford, C. E., and Holroyde, D., *Industrial Railways and Locomotives of County Durham Part 1* (Melton Mowbray: Industrial Railway Society, 2006) p. 268

lown to the dam at Waskerley reservoir was likely the location for an accident in 1881 hat mirrored the opening day accident at Weatherhill in 1834 on a smaller scale. A set of 'small trucks' carrying directors of the Weardale and Shildon Waterworks Companies an away from the top of the incline and were derailed after running over the leg of one occupant who fell out, unsurprisingly injuring the man whose leg caused the derailment, and also injuring another who was thrown out of the truck.[77] The third reservoir, Hisehope, was joined to the line from Meeting Slacks by a standard gauge line from around 1896 to ts completion in 1906. (For more information on the railways used in the construction of reservoirs, see Harold D. Bowtell's *Dam Builders' Railways from Durham's Dales to the Border*, Plateway Press, 1994)

What is believed to have been the worst accident on the line since the opening day runaway in 1834 occurred on the night of 21 November 1873 on a steep section of the ine between Burnhill and Rowley. A locomotive hauling twenty-one wagons loaded with ronstone, and a brake van at the rear, was en route to the Consett ironworks from the mines at Eston near Middlesbrough. Heading towards Rowley on a stretch of line with a downhill gradient of around 1 in 40 with the rails greasy following a rain shower, the driver, Joseph Johnson of Shildon, found he wasn't able to slow the train down. Johnson said to his fireman, Robert Walker, that they 'would never reach Rowley, and that they had better prepare for another world'. Almost as soon as he had said this, as the train reached a curve the locomotive came off the rails, pulling the rest of the train with it. This appears to have been just passed White Hall Farm where, heading towards Consett, the line curves to he left, just after the junction where the deviation line to Burnhill meets with the old line at a lower level, which was still open and led to the coal depot at Whitehall. The newspaper report described the carnage caused:

> Some idea of the speed at which the train was going may be formed when we state that the spot where the engine left the rails to where it came to a standstill is fifty yards. After going for that distance, it appears to have turned completely upside down, while the tender was thrown upon its side, both being smashed to pieces; and some of the laden trucks were completely demolished. The accident was witnessed by the station-master, Mr Featherstone, and several others, who procured lights, and at once proceeded to the scene of the disaster.

The guard's brother, Henry Long, a labourer, was travelling in the brake van – when the accident occurred he shouted out for his brother, and the driver Johnson 'told me to go back and stop another engine which was coming after us. I went and showed a light, and stopped the other engine, and then came back, when I saw Walker, who was sitting up, supported by some men. I then went and assisted my brother.'[78]

Among those from Rowley going to the wreck was goods porter Thomas Marshall. 'I was coming home from work, about twenty minutes past seven, I heard a train coming down the incline at the Burnhill elevation, and I thought by the noise that she was coming fast, and then when she came down on to the level of the deviation I heard a noise like

77 *Northern Echo*, 8 August 1881
78 Northern Echo 26 November 1873

steam blowing off strongly, and I went to the place and found the engine and train off the way. The engine was lying on her side, and I saw two men in the field, clear of the engine. I assisted to get one of them up.[79]

The man assisted by Marshall was the guard Joseph Long, who had a miraculous escape – he was travelling along the wagons pinning their brakes down when the derailment occurred, and considering how smashed they were, he was very fortunate to get away with bruising. The other man in the field was the engine driver, who had suffered cuts and bruising especially around his head and face. After he gave his instructions to Henry Long he was taken to the nearby farmhouse for attention.

> The whereabouts of the fireman could not be ascertained for a considerable time, and when he was discovered, it was found impossible to extricate him from the debris. The unfortunate man was fastened between the engine and the tank of the tender, and portions of these had to be removed before he could be reached. He is dreadfully scalded, and in addition to severe cuts on the head and face, he is, it is feared, fatally injured internally.[80]

Fireman Walker and guard Lang were taken to the waiting room at Rowley station, stationmaster Featherstone attending to them while Dr Dale and Dr Savage of Consett attended swiftly. At about midnight the injured men were put in a carriage to be taken back to their homes at Shildon but the train was stopped at Tow Law and Walker lifted out.

Meanwhile Mr Boggett of Waskerley had been telegraphed and made his way to the scene of the accident with a gang of labourers. The Down line had 'entirely disappeared for a distance of upwards of forty or fifty yards, the embankment having given away, and it will take a week at the soonest to replace it'. The Up line was able to be cleared away quickly though.[81]

Inspector over the platelayers William Wayper of Tow Law described the scene the next day:

> On Saturday morning, I visited the place where the accident happened; at the foot of the Burnhill deviation the wreck was all laying, and the engine was laid on her broadside in a field, a distance of about twenty yards from the line; there were 21 trucks behind the engine, which were all more or less broken up, and the stone with which they had been laden strewn about. I examined the way, and a great many of the metals had been torn up bodily. I don't know the gradient of the line at that part. I did not see anything likely to cause the engine to jump the metals. I examined the way before the accident, and found it in good order. Where the train left the rails there is a nice easy curve; the gradient is not very great, but it is very heavy a little further up. The train had left the metals on the inside of the curve. I have known a train run amain down this part of the line before.

79 *Northern Echo*, 26 November 1873
80 *Northern Echo*, 24 November 1873
81 *Northern Echo*, 24 November 1873

Charles Gowland.
(Kind courtesy of
Vanessa Skarpari)

The superintendent of the Weigh and Works Department of the Darlington section of
the NER, responsible for this part of the line, James Ianson, described the line and the
likely cause:

> The point of the accident is 280 yards from Cold Rowley Station, on the west side. The
> gradient falls one yard in 132. To the west of that there is a short piece which one yard
> in 100, and to the west of this for about a mile and a half the gradient varies from one in
> thirty-six to one in sixty-six. I attribute the cause of the accident to the engine coming on
> to a more level gradient, and the trucks pushing it behind.[82]

82 *Northern Echo*, 26 November 1873

Twenty-five-year-old Robert Walker succumbed to his injuries and died on the morning o 24 November. The inquest on 25 November was adjourned to 15 December to allow the guard and driver to attend. Johnson, the driver, 'gave it as his opinion that the engine ran away in consequence of deficient break(s).' The guard, Joseph Long, 'said he put down as many breaks as he had time, but could not prevent the train getting amain.' The jury gave a verdict of accidental death.[83]

Among the railway families at Waskerley were the Gowland brothers Charles and John who were engine crew. In April 1889 after he returned home from work, Charles Gowland aged just forty, lay on the floor and began rolling around in agony. Dr Hood of Tow Law was sent for, who arrived after a few hours, but Charles soon died leaving a widow and five young children. He had suffered from chest pain for some time, and would on occasion have 'strange fits'. One shocking occasion occurred while his brother John was firing for him (John was described as 'generally being with him' suggesting they usually worked together): as Charles was driving at a very slow pace down Lanchester Bank he suddenly fell off the locomotive onto the adjacent running line, and if his brother had not been so quick in getting him off the rails he would have been run over by an oncoming train. An inquest held in the schoolroom at Waskerley a few days after his death saw Dr Hood give his opinion that death was owing to congestion of the lungs, which the jury unanimously agreed with.[84]

Some – presumably relatively small – change was made to the Weatherhill engine in 1890: the engine, alongside the road at the top of the steep gradient down to Crawleyside had a steam pipe that ejected steam 'in large quantities close by the road side, which ever sometimes enveloped the road'. This had the unsurprising effect of frightening horses endangering people either riding or travelling behind them. A meeting of the Weardale Highway Board had raised the issue previously and written to the NER forcing the modification.[85]

At about eight in the morning on Monday 21 April 1890, the death of a man at Waskerley occurred while unloading a wagon. James Guy, aged sixty-six, was unloading a wagon full of ballast in the sidings at Waskerley. After withdrawing the bottom boards of the wagon to discharge its load, he jumped on top of the wagon to push the ballast through. He fell straight through the gap he had created, and the huge quantity of ballast which came down at the same time buried him alive, being beyond resuscitation when he was pulled out.[86] Another tragedy involving a loaded wagon happened to a group of boys who were playing at the Whitehall coal depot on Sunday night, 28 June 1891. One of the sprags securing the wheels of one of the wagons loaded with ganister stone in the sidings came out, causing the wagon to start rolling. An eleven-year-old boy, Joshua Frederick Symm, was knocked down by the wagon and his left leg was run over by it just below the knee. Although he was taken to his home at Castleside and was attended to by doctor, after amputation at the knee he did not recover and passed away the following morning.[87]

83 *Northern Echo*, 16 December 1873
84 *Consett Chronicle*, 27 April 1889
85 *Durham County Advertiser*, 14 March 1890
86 *Daily Gazette for Middlesbrough*, 21 April 1890
87 *Newcastle Daily Chronicle*, 30 June 1891

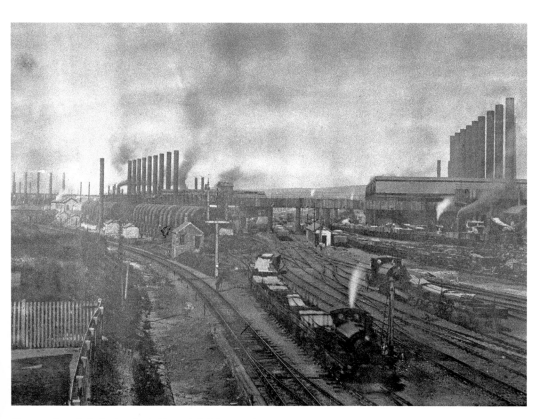

Consett Iron Works in 1896. (Beamish Museum)

Strong winds described as 'the most violent and destructive experienced in many years' in February 1894 caused widespread damage across the area. The waiting room on the south side of Rowley station 'was swept entirely away a distance of some twenty yards'.[88] Another unusual incident at Rowley followed a few months later: at around one o clock in the morning of 21 September 1894, as an excursion train from Middlesbrough was passing through Rowley at a speed of around 20 miles an hour on its way to Consett, Thos Raine of Castleside opened the door of the carriage he was in and either jumped or fell out onto the platform, injuring his head and face. The porter went to fetch the stationmaster, Hall, while the stunned Raine crawled along the platform and then fell onto the rails where he was found unconscious. A stretcher and medical man were brought down from Consett by locomotive, and the man was taken home. To add to the bizarre nature of the incident, his brother, who was in the same compartment, knew nothing of what happened other than the carriage door opened then closed again! It can only be surmised that Raine decided he would save himself a long walk home and severely misjudged the speed of the train.[89]

88 *Durham County Advertiser*, 16 February 1894
89 *Newcastle Daily Chronicle*, 21 September 1894

Snow Business

The extreme weather and exposed nature of the line saw it particularly susceptible to difficulties owing to snow, a recurring problem throughout its history. In late January 1847 the line from Stanhope to Waskerley was closed for a week owing to snow, and ten years later on Monday 2 February 1857 the S&DR Haulage Contractors reported 'the line from Stanhope to Waskerley has been closed by snow for one week but is this day open'.[90]

Q6 class locomotive No. 3404 (based at Consett from 14 January 1946 and renumbered 3404 from 2247 that August) stuck in snow at Rowley in 1946. (Beamish Museum)

90 TNA RAIL 667/59

In early 1860 a snowplough was built at Waskerley, and it was not long before nature provided a chance to use it:

On Wednesday week the snow lay very thick, and, drifted by a north wind, in the cuttings of the line it was four feet deep. On that day a new snow plough, built at the Waskerley Works a few weeks ago, was (to test its merits for the first time) placed in front of an engine, in order to clear the line from Waskerley to Stanhope. The experiment was a complete success. The plough cleared four miles of the line in half an hour, a work which would have occupied thirty men a day and a half each.[91]

A few months later a snowstorm saw all trains completely stopped west of Waskerley as the line was covered under snow up to four or five feet thick, men spending the whole day clearing snow between Waskerley and Stanhope.[92]

Snowploughs were not an instant solution, especially as they could not be everywhere at once, and large gangs of men were still needed to move snow, as well as to accompany the plough to shift broken snow thrown by the plough, and deal with frozen points or other infrastructure. A heavy snowstorm over Weardale for most of January 1886 cut the railway off and 100 men were sent up to Waskerley to help clear it.[93] Later that year, the body of sixty-five-year-old platelayer Thomas Pickering was found in the cess next to the track at the Whitehall coal depot half a mile west of Rowley station. It was conjectured he had been clearing out snow from the points but owing to the constantly falling snow had not seen the passenger train from Darlington to Burnhill, the buffers of which must have struck and killed him. The coroner's inquiry, which was held in the waiting room at Rowley station, recorded accidental death.[94]

The construction of a new fleet of snowploughs by the NER in the late nineteenth century aided in keeping the line open following snowfall. A new snowplough was called on to deal with the snow up at Waskerley in March 1888. Wilson Worsdell, Assistant Locomotive Superintendent (later Chief Mechanical Engineer) of the NER, was also present to see its progress.[95] A journalist account of its use was published in the *Huddersfield Examiner*:

After a short stay at Consett, we were taken on towards Rowley and Burnhill Junction. The snow here had been heaped high above the rails, and there were still numbers of men at work, clearing the way and making it fit for traffic. At Burnhill our position was reversed, and we proceeded backwards towards our destination, so that the plough, instead of being dragged, was now being pushed along. The country we entered was of a most bleak and desolate description. For miles around there was nothing to be seen but wild moorland, shrouded in virgin snow, whose varying undulations gave it the appearance of a vast white sea foam. The horizon, where earth and sky appeared to meet, was half hidden by the snowy mist that filled the air, and we could see how the wind demolished a

91 *York Herald*, 4 February 1860
92 *York Herald*, 2 June 1860
93 *Shields Daily News*, 25 January 1886
94 *Durham County Advertiser*, 17 December 1886
95 *Newcastle Evening Chronicle*, 14 March 1888

Dramatic photograph of an NER snowplough in action on the line. (Kind courtesy of Chris Freeman, not to be reused)

snow-wreath in one place and formed one in another. When we arrived at Waskerley we were told that the drift that needed clearing was just ahead. In order to view the working of the plough better, some of us left the snugness of the interior, and obtained places on the foremost engine – that immediately behind the plough. The wind was cruelly cold, and cut one like a knife, and the drifting snow filled the eyes, and seemed to penetrate through one's clothing, right to the very bone. In front, the track was visible, so long as one could keep one's eyes open, for a mile or more, but the lines were in most places hidden beneath several feet of snow. But the plough made short work of the accumulation, for it was still soft, and shifting. When the stem of the huge implement, which weighs about thirty tons, came upon a drift, it cut through just as the prow of a vessel cleaves a wave. The soft snow thrown lightly on each side, and clouds of white spray were whirled into the air. But the drift, though a long one, was nowhere very deep, and the snow-plough probably never had an easier task allotted to it.[96]

The snowplough, and Worsdell, were involved in a horrific accident soon after at Annitsford in Northumberland on the East Coast Mainline when approaching a stranded train at low speed. The shape of the plough forced the locomotive of the stuck train on top of the plough, the locomotive crushing the wooden vehicle. Worsdell's friend, F. G. Hulburd, was

96 *Huddersfield Examiner*, 17 March 1888

severely burned when the stove in the snowplough crushed him and died a month later, and Worsdell suffered a broken leg.

On the morning of 8 January 1895 there had been an 'exceptionally heavy fall of snow' in the Consett area, the line being blocked between Tow Law and Burnhill. The line was cleared by midday owing to gangs of men clearing the snow, reportedly up to 2- or 3-feet thick, and double-headed passenger trains were able to run as usual. On the night of 24 January 1895, a 'perfect blizzard' swept across the moors, and the line was blocked by snow between Tow Law and Burnhill stations. The first to become stuck was a mineral train, which became 'embedded' in the snow. The 08.15 train from Blackhill made it as far as Burnhill before having to turn back, and the train from Darlington reached Tow Law then had to return. The mineral train, after being dug out, reached Consett shortly before 10.30 and the afternoon and evening passenger train service were able to run as timetabled.[97] In early February a notice was published on the front page of the *Newcastle Daily Chronicle* informing the public that owing to snow blocking the line from Waskerley to Stanhope Kilns there would be no goods service to or from Parkhead or the Stanhope Kilns and none could be accepted until further notice.[98] At the other end of the weather scale, in the summer of that year a powerful thunderstorm caused damage across the North East from Richmond through to Middlesbrough and up to Consett, and part of the destruction caused was the demolishment of a corner of the goods warehouse at Rowley station by lightning.[99]

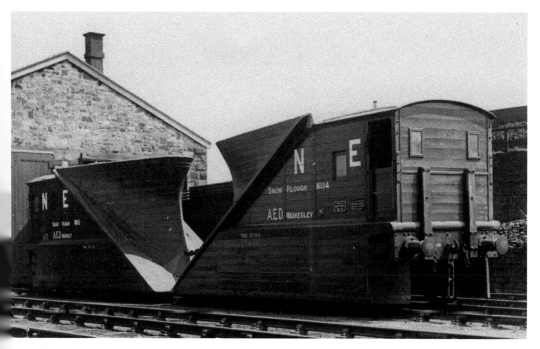

NER snowploughs No. 5 and No. 15 at Waskerley. (Ken Hoole Collection – Head of Steam – Darlington Railway Museum)

97 *Sunderland Daily Echo and Shipping Gazette*, 26 January 1895
98 *Newcastle Daily Chronicle*, 5 February 1895
99 *Daily Gazette for Middlesbrough*, 3 July 1895

Heavy snow on Christmas Eve 1901 meant above Castleside it was impossible to use the road, and the Consett Co-operative Society's horse-drawn rolley was stuck in a snowdrift despite the assistance of additional horses. The goods were taken to Rowley station, and a special train was run to Burnhill from where the parcels of food and other provisions were carried by men through several feet of snow to the otherwise cut-off community at Waskerley.[100]

In late December 1906 a goods train with no less than four locomotives became stuck in a snowdrift between Consett station and Consett junction, and a train between Tow Law and Rowley was brought to a stop owing to snow in a deep cutting, with the first train from Darlington to Blackhill arriving over an hour late – the line was only kept open by a snowplough train travelling over it constantly.[101]

On Friday 28 January 1910 the Blackhill to Darlington passenger service, consisting of three carriages hauled by two Fletcher '398' class 0-6-0 locomotives (an additional engine had been provided as a pilot owing to the snow), proceeded no farther south than Rowley owing to the line ahead being blocked with snow. The Waskerley based snowploughs, No. 5 and No. 14, had derailed at Burnhill while doing a run to keep the line clear for the last Blackhill to Saltburn train.

The Darlington train at Rowley could not return to Blackhill, so was stranded. It was decided to keep the locomotives in steam and provide steam heating for the carriages, snow

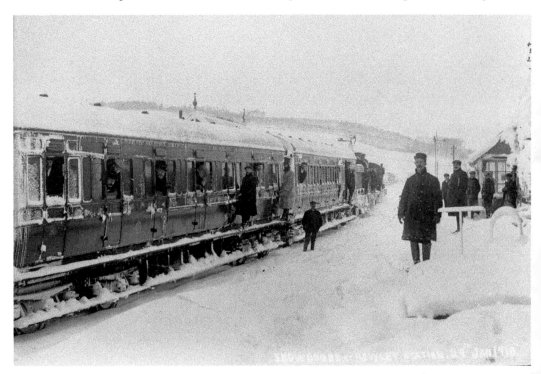

The snowbound train with Bainton, the stationmaster, in the foreground. (Beamish Museum)

100 *Shields Daily Gazette*, 27 December 1901
101 *Shields Daily News*, 29 December 1906

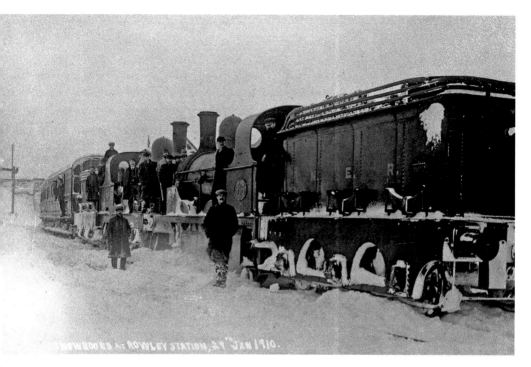

The two snowbound '398' class 0-6-0 locomotives at Rowley. (Beamish Museum)

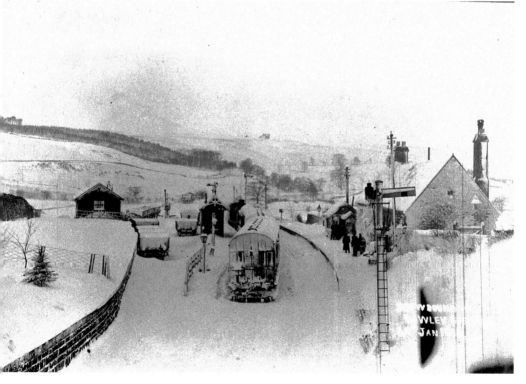

General view of Rowley with the stranded train. (Beamish Museum)

being shovelled into the water tanks on the locomotive tenders to keep the water levels up. There were seventeen people stranded including the locomotive crew – the men slept in the carriages while the solitary lady passenger stayed in the house of the stationmaster, Bainton. The stationmaster's wife had plenty of provisions, but even with the addition of a large joint of meat, which was originally destined for a farmer 3 miles away, these soon went down while catering for seventeen extra people, and the stranded lady passenger helped with the cooking. The snowploughs were eventually able to get through late in the afternoon of Sunday 30 January, the stationmasters son describing the view of the ploughs throwing snow to the side of the tracks for some distance as 'marvellous'. The line was reopened as a single line only, and the locomotives took one carriage each. The event left a stronger impression than just these photos – one of the stationmaster's sons later met and married the niece of one of the stranded locomotives firemen!

Snow continued to affect the line until closure, with impressive colour film of a Q6 powered snowplough train clearing snow above Waskerley in British Railways days existing in the National Railway Museum archive.

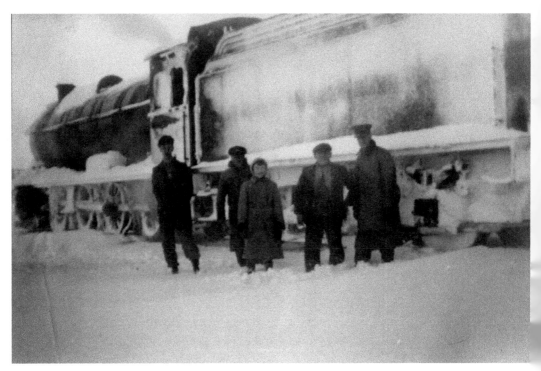

Q6 locomotive in the snow. (Kind courtesy of Matthew Oliphant, not to be reused)

The Twentieth Century

Burnhill station was a crossing point on the line for passenger services, and trains usually arrived within a minute of each other. The sudden rush of work for an otherwise quiet station was dealt with by stationmaster George Smith, who would deal with the train from Darlington and Bishop Auckland while the porter Thomas Jenkins would attend to the train from Blackhill. This required the stationmaster to cross the tracks, and it had been known for him to do so at the last moment. A double-headed excursion train was coming in from Blackhill at 08.34 on the morning of Saturday 20 July 1901, about ten minutes late, on its way to Saltburn. As it approached the station, the driver, John Raine of Waskerley, blew the whistle, and again as he saw Smith leave the booking office on the west platform. As the train drew into the platform it was travelling at about 5 or 6 miles per hour. Smith then hurried down the platform and crossed the tracks, Raine whistling a third time as he saw him about to cross in front of the train. Porter Jenkins had warned Smith the train was coming and shouted to him but he did not appear to notice. Smith was 'caught by the buffers of the first engine, and instantly killed, his head being almost severed from his body'. Raine stopped the train and found Smith's body lying between the rails. Unsurprisingly it was reported that Smiths death 'caused quite a sensation in the district'.[102] The coroner said that no blame was attached to anyone else, and a verdict of accidental death was brought by the jury.[103]

Comfort for waiting passengers at Rowley was greatly improved around 1906 when the open arches at the front of the station were enclosed with a wood and glass screen, changing the appearance of the station and giving much more protection against the weather. In August 1910 it was customary that passenger tickets for Blackhill were collected when the train stopped at Rowley when, as stationmaster Bainton was dealing with one compartment, a man called Turner went to the carriage door and demanded his ticket be returned. Bainton said it was alright, but Turner grabbed the stationmaster, pulled him out of the compartment and 'dragged him about the platform' until a police officer intervened.

102 *Dundee Evening Telegraph*, 22 July 1901
103 *Newcastle Daily Chronicle*, 24 July 1901

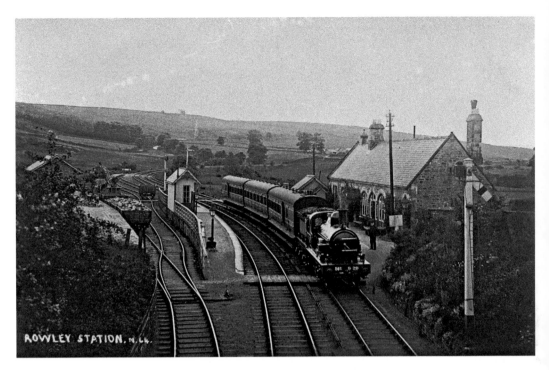

NER 2-4-0 No. 929 with a rake of three elliptical roof bogie carriages. (Beamish Museum)

The defendant claimed he'd only touched Bainton on the shoulder and asked for the ticket to be returned. The magistrate found him guilty and fined him 20 shillings plus costs.[104]

The problems of trespassing on the railways, despite the NER having large cast-iron notices warning against this, was a frequent issue. The consequences of what could occur were reported on in August 1912:

> Mr Thos. Purchas, of Blackett Street, Newcastle, had a narrow escape on the North Eastern Railway near Rowley Station, on Thursday evening. He was walking from Stanhope, and was proceeding along the side of the railway on approaching the station, when he was caught by the left buffer of the engine attached to the passenger train due to arrive shortly before 5 p.m. Mr. Purchas was, fortunately, knocked clear of the rails, but the force of the impact fractured two of his ribs, and he was injured about the chest through the fall on the side of the line. He was picked up and carried to the station by Mr. Pybus, and was conveyed by the train to Blackhill Station, where he was attended by Dr. A.D.M. MacIntyre, of Consett. Mr. Purchas was sent to Newcastle by the 6.14 train from Blackhilll.[105]

Another incident at Rowley involving someone being hit by a locomotive, although in this instance a railway employee, happened in August 1913. Porter George Blides was crossing the tracks from behind a goods wagon at Rowley when he was struck by

104 *Newcastle Daily Chronicle*, 16 September 1910
105 *Newcastle Daily Chronicle*, 24 August 1912

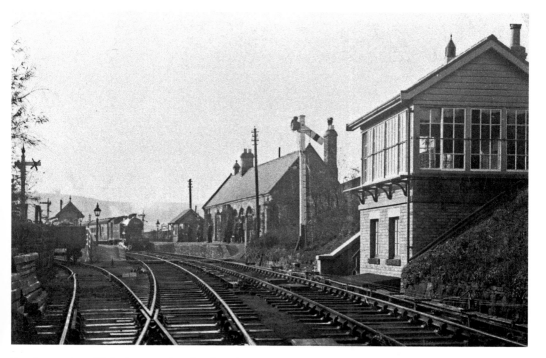

Rowley station, likely in 1914 shortly after the new signal box was built. At the platform is an NER D Class 4-4-4T, a large passenger tank locomotive design used on other lines – as they were built at Darlington in 1914 it is likely on trials hence its appearance here. The lineside garden between the signal box and platform looks to be far from its usual immaculate condition, probably as a result of the new signalling equipment being installed. (Beamish Museum)

a locomotive which he had not noticed. He was taken to Newcastle Infirmary with a depressed fracture of the skull.[106]

Another change to the setup at Rowley came in 1914 when the small signal box on the platform was replaced with a larger box nearer the bridge. The change was made owing to the track between Rowley and Hownes Gill being reduced from double to single track and subsequent changes to the operation and signalling apparatus, but the double track between Rowley and Burnhill junction remained.

The First World War saw great changes on the NER. Not only were its men leaving for the armed forces (18,339 NER men served in the war, 34 per cent of staff of military age), women joined the NER in unprecedented numbers too with a workforce of 7,880 women by the end of the war compared to 1,470 at the start, not including the thousand or so employed at the NER managed munitions factory at Darlington North Road. The NER was required to move men, munitions, and all other items necessary for the war effort and was attacked from the sea in coastal bombardments and from the air during Zeppelin airship raids. An assault of a rather different kind occurred at Rowley on 12 June 1915. Charles Nixon, a resident of Rowley, arrived there on the 12.19 train and promptly threw a stick at stationmaster Pybus, who was stood on the platform. He then went into the waiting room where there was a

106 *Newcastle Daily Chronicle*, 28 August 1913

woman and several children present 'and used such foul language that he was requested to leave the premises'. Nixon then 'declared that he would fight any ___ about the station, and struck at the stationmaster' (what he said between 'any' and 'about' is put as a deliberate gap, as copied here, so it is up to the reader to insert a suitable profanity – presumably it was too shocking to be printed in the newspaper report!).

Porter-signalman Henry Almond went to stationmaster Pybus's assistance, Nixon striking Almond several times and then leaving the station. Nixon returned at 13.00, entering the office and striking Pybus on the neck, and when Almond entered shortly after, Nixon struck him with several blows again. After being 'ejected from the premises', Nixon returned back half an hour later and 'again abused the complainants', who sent for the police and again removed Nixon from the station. Clearly determined, Nixon returned yet again at 15.45, striking Pybus and Almond, and again was ejected, this time with the assistance of a neighbour who had been sent for by Almond. When Nixon was charged several weeks later at Consett, being prosecuted by the NER, it was said by his defence (who had advised Nixon to plead guilty) that 'there had been some misunderstanding about an excess ticket, but this did not justify the defendant's conduct', adding that 'Nixon had come into some property, and become addicted to drink, the result being that he had been confined for three months in an asylum'. Nixon was charged £1 for each case – one for assaulting Pybus and the other for assaulting Almond – and the fees of the prosecuting solicitor and witnesses were allowed.[107]

While on duty on the Crawley incline, Albert Vipond, son of the incline engineman, was killed after being run over by a wagon on 5 May 1916.[108] Another sad incident occurred a few months later at Whitehall on the narrow-gauge tramway that ran (partly along the original S&TR route) from the coal depot sidings, then north to a quarry at Healeyfield. Seventeen-year-old Lily Brown had taken her brothers tea to him at the quarry, and after he'd finished his meal, she had jumped into one of the empty horse-drawn tubs. When the driver started the horse, the sudden movement caused her to fall out. The only visible sign was a small bruise on her temple but she died almost immediately.[109]

Another effect of the war that reached the out-of-the-way railway community on the line was that of food shortages, particularly from 1917 after the second unrestricted phase of submarine warfare by the Imperial German Navy, with U-boats sinking merchant shipping at an alarming rate, which Britain heavily relied on for foodstuffs. The NER ran a large campaign to encourage growing food and keeping animals on allotments using railway land, and by May 1917, ten additional fenced allotments had been created at Waskerley on NER land, which soon after creation were all taken.[110] German prisoners of war were held near to the line in a working camp at Healeyfield, which was established in August 1916, to work the ganister quarry served by the tramway from Whitehall coal depot. Elsewhere in the area, German prisoners of war worked in other quarries and were also put to work clearing snow off the railways when required.

The NER raised its own unit of men for the British Army at the start of the war – the 17th (Pioneer) Battalion, Northumberland Fusiliers, which spent a lot of its time on the Western

107 *Newcastle Daily Chronicle*, 6 July 1915

108 *Hartlepool Northern Daily Mail*, 6 May 1916

109 *Newcastle Journal*, 13 September 1916

110 *North Eastern Railway Magazine*, May 1917 p.93

Above: Cartoon of Rowley station dated 1918 by local photographer W. Bainbridge. (Beamish Museum)

Left: German prisoners of war clearing the line around Waskerley in the First World War. (Beamish Museum)

Front as a dedicated railway construction unit. Rowley station's lad platform porter Albert Lawson joined the NER Battalion and was wounded in late 1917, but not severely.[111, 112] Closer to home, a sad accident occurred on the night of 29 October 1917. Mrs Thompson, her three-year-old son and fourteen-month-old daughter had been shopping in Consett and took the train from Blackhill to Burnhill, arriving at 6.39 p.m. They were walking from Burnhill station along the track, with their neighbour Mrs Woodhead, towards their home at Saltersgate Cottages when they were struck by a special goods train that had been following the passenger train. It was getting dark and it was a windy night, which could have masked the noise of the train, as they did not appear to notice it. Mrs Woodhead was clear of the line but Mrs Thompson, holding her infant daughter in her arms, was knocked down and suffered a badly injured arm and fourteen-month-old Mary Julien Thompson was killed instantly. Three-year-old Robert was knocked down by the locomotive and stayed in between the rails until the train passed and was unhurt.[113]

Wartime increases of iron and steel making meant a commensurate increase in limestone requirements. The strain after many years of use by the Weatherhill engine meant that on 7 December 1916 the NER authorised a replacement at a cost of £7,660, which entered service in 1919, and at the same time the incline was rebuilt in places to even out the level from what seemed to have been its original 1834 profile. The Crawley inclines' original Hawks & Co. engine had already been replaced by 1919 with a marine-type steam engine – the exact date for the change is not known but was described at the time as 'modernised recently' with the same engine house used with some modifications.[114]

A spate of robberies hit stations in the area in December 1919. Striking at night, the thief or thieves had first stolen from Rowley and Burnhill before rifling the till and taking 116 half-penny stamps at Witton-le-Wear, the clerk's bicycle, and examining Christmas presents including taking bottles of whiskey. At Wear Valley Junction £3 was taken from the till and some presents were believed stolen.[115]

A veteran of the line retired on 4 November 1922 – the seventy-year-old Mr John Gowland of Waskerley, whose brother Charles had died at Waskerley in 1889. Notice of his retirement tells of his fifty-six years of experience on the railways:

He started on the Weatherhill and Crawley Inclines and then became a fireman on one of the old 'Collier' engines similar to the 'Derwent', which is now preserved at Bank Top Station, Darlington. At that time firemen had to clean the engine 'from top to bottom', and had many other duties to perform. After firing for 19 years, Mr. Gowland was made a driver and for several years was in charge of Engine No. 1146, named 'Ostrich'. Twenty years later, owing to failing eyesight, he had to take up the duties of stores issuer and messenger. Mr. Gowland can tell of the trials of an engine driver at a time when there were no automatic brakes nor block system.[116]

111 *North Eastern Railway Magazine*, September 1918
112 War Office casualty list, 29 December 1917
113 *Newcastle Journal*, 31 October 1917
114 *North Eastern Railway Magazine*, July 1919 pp.113-6
115 *Newcastle Daily Chronicle*, 27 September 1919
116 *North Eastern Railway Magazine*, January 1923 p.19

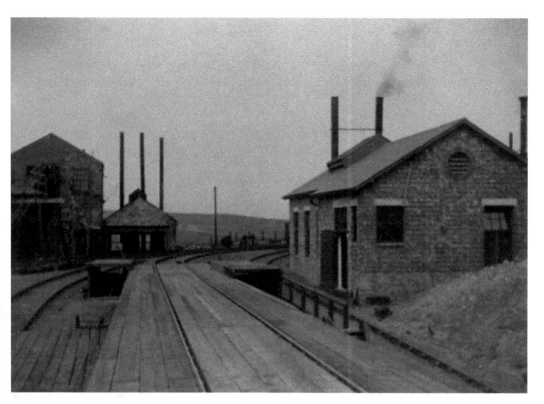

Head of Weatherhill incline with the new, 1919-built engine on the right and the original S&TR engine still in situ on the left. (Richard Charlton Collection)

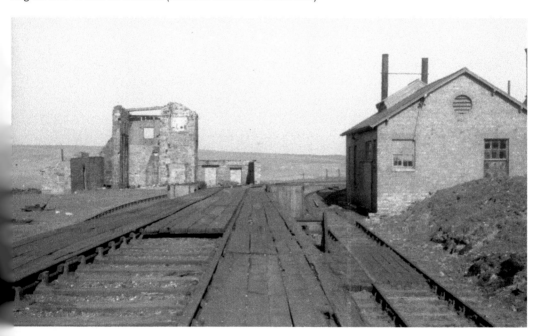

The same view years later, when the original engine was removed for display at York. (J. W. Armstrong Trust)

The NER was grouped in 1923 to become part of the London & North Eastern Railway (LNER). Other than a change of livery for locomotives, rolling stock and infrastructure, Parkhead goods station was renamed Blanchland to avoid confusion with the larger Parkhead station elsewhere on the LNER at Glasgow. Another veteran of the line, the Weatherhill engine, found itself brought back into use in 1924. The base plate of the new engine broke, and while it was being repaired, two locomotives were brought up and provided steam to the original engine for two months. Following this, it remained in situ, surviving long enough to be removed in 1931 and put on display at the York Railway Museum at Queen Street, and from there relocated to the National Railway Museum at Leeman Road, which opened in 1975, and is frequently demonstrated by electric motor, albeit with many replacement parts.

Right: This privately owned battery-electric locomotive was used on the Weatherhill & Rookhope line from the 1920s, seen at Parkhead station in October 1951. (Beamish Museum)

Below: Crawley engine house seen in 1938. (J. W. Armstrong Trust)

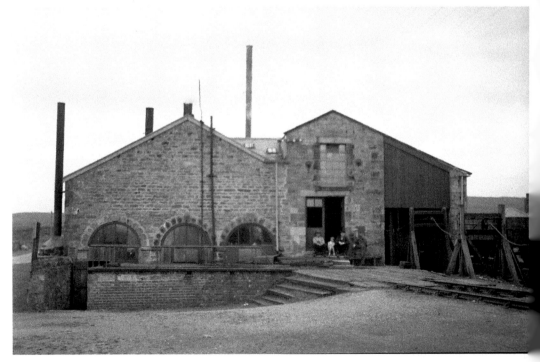

Contraction of Services, Closure and Rebirth

While the passenger service along the Wear & Derwent Railway provided a vital link to the wider world for the local inhabitants, it was never particularly busy. Economic conditions in the 1930s saw the LNER passenger services in North West Durham come under the gaze of management, with falling passenger figures linked to a rise in motor bus services in the area. The decision was taken to cease passenger services between Blackhill and Tow Law,

Two girls on the road bridge at Rowley on 3 September 1937 looking at the cast-iron 'bridge diamond' warning sign fitted to many road bridges over railways by the North Eastern Railway warning of weight restrictions. (Beamish Museum)

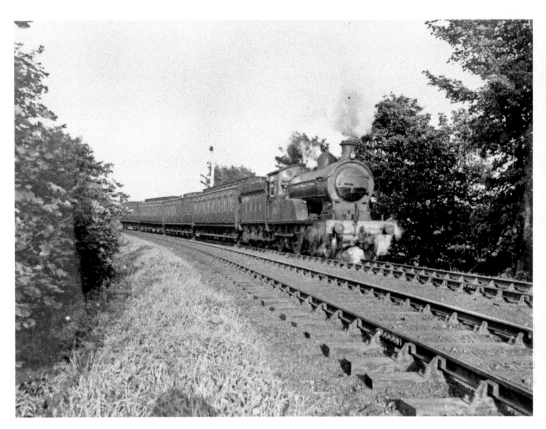

1920s or 1930s view of a former North Eastern Railway R Class 4-4-0 No. 1042, now under London & North Eastern Railway ownership and designated a D20, between Rowley and Burnhill. (Beamish Museum)

thus closing Rowley and Burnhill stations entirely to passengers, from 1 May 1939. Trains from Darlington now terminated at Tow Law. Services in the area were also affected by the closure of passenger stations and service on the Lanchester Valley line, a local newspaper reporting that the closures resulted in upset 'among residents of North-West Durham at the decision of the London and North-Eastern Railway Company.'[117]

Burnhill station closed completely with parcels traffic going to Waskerley, although Rowley stayed open for goods traffic. Rowley stationmaster T. P. A. Eccles, who had been in post at Rowley for three and a half years, was transferred to Brompton station near Northallerton. The porter-signalman J. R. Barron transferred to Etherley station.[118] Other than cessation of passenger services, it would have other effects on the local community, and in early July Healeyfield Parish Council were asked by local residents to approach the post office with regards to granting an afternoon collection for letters and parcels and also provide a telephone kiosk for the area.[119] All railway access to the south ended soon after, as a munitions storage depot was built along the line at Saltersgate between Tow Law and

117 *Newcastle Evening Chronicle*, 15 April 1939
118 *Newcastle Evening Chronicle*, 18 April 1939
119 *Newcastle Evening Chronicle*, 5 July 1939

View from an enthusiasts special nearing Burnhill junction, with Saltersgate ammunition depot visible in the surrounding area. (A. L. Barnett/North Eastern Railway Association)

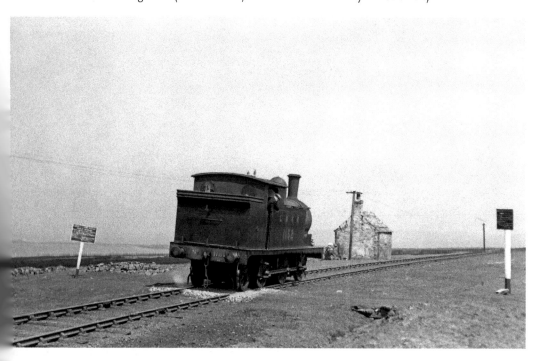

NER B class (LNER N8) No. 1152 at the site of Meeting Slacks engine house between Waskerley and Parkhead. (Tom Smeaton/North Eastern Railway Association)

Burnhill Junction to store the produce of Newton Aycliffe Royal Ordnance Factory. This effectively split the line in two with the line being fenced off at each end of the depot, although the disused line in-between was not removed for another thirteen years. The loss of the line to the south together with the LNER consolidating locomotives in the area at Consett resulted in Waskerley shed – by then housing just three locomotives – closing in 1940. Although the goods station remained open, Waskerley had lost its main reason for existence and the population soon declined.

Although the Consett Iron Company had extended their limestone quarry at Ashes eastwards after the First World War, they were increasingly acquiring limestone from other sources, and as the more easily workable seams were exhausted at Ashes it became more costly to quarry there and was closed in the 1940s. The limekilns at Lanehead quarry had come back into use in the 1930s, but the use of road transport was more efficient to serve them – especially as the covered railway wagons, which were better suited for transportation of lime, could not fit through Hog Hill tunnel. With very little traffic using them, British Railways (formed in 1948 and nationalising most of Britain's railways including the LNER) closed the inclines at Crawley and Weatherhill inclines in 1951. The rest of the line from Consett to the head of Weatherhill incline continued to serve the goods stations at Blanchland (Parkhead), Waskerley and Rowley together with traffic from quarries along the line.

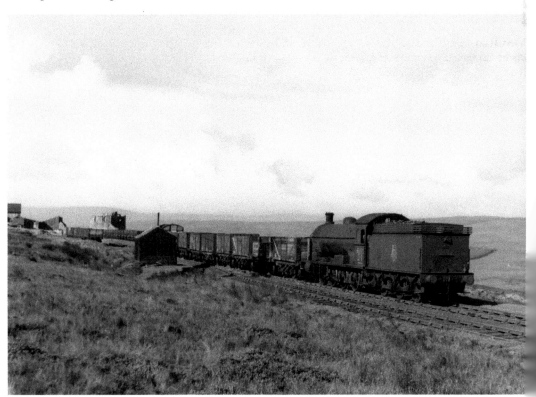

Q6 class locomotive No. 63372 at the head of Weatherhill incline sidings with a goods train in the British Railways era and the original engine house remains still visible. (Ken Hoole Collection – Head of Steam – Darlington Railway Museum)

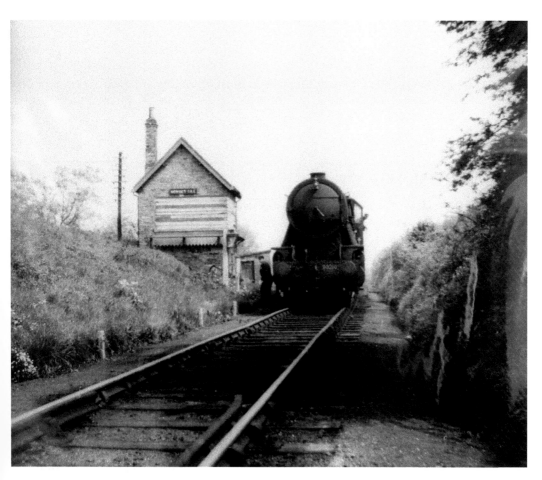

Built for the War Department in 1943, British Railways 2-8-0 'Austerity' locomotive No. 90210 at the disused Hownes Gill signal box on the Consett side of the viaduct. (Beamish Museum)

Although still served by one train a day up until the 1960s and then reduced to several a week, Waskerley's much-reduced status as a railway centre, and the singling of the line from Burnhill and Rowley in the 1950s, means the line must have had a derelict air about it. The steadily declining state of Rowley station, the gaunt shells of buildings at Burnhill and the remains of Waskerley following the sheds and other buildings being demolished in the 1950s give these former epicentres of life an eerie appearance in photographs. The sand quarry at Parkhead was originally served by sidings from the goods station, but after the closure of the inclines, instead used the extent of the line up to the head of Weatherhill incline with a reversal to the quarry's loading hoppers.[120] The sparse goods traffic was not enough to keep the line financially viable and the goods stations at Waskerley and Blanchland (Parkhead) closed in August 1965, and Rowley goods station followed on 6 June 1966. The Waskerley branch officially closed on 29 April 1968, with the line from Consett to Burnhill closing on 1 May 1969 after the closure of the Saltersgate ammunition depot in

120 Mountford, C. E., and Holroyde, D., *Industrial Railways and Locomotives of County Durham Part 1* (Melton Mowbray: Industrial Railway Society, 2006) p. 151

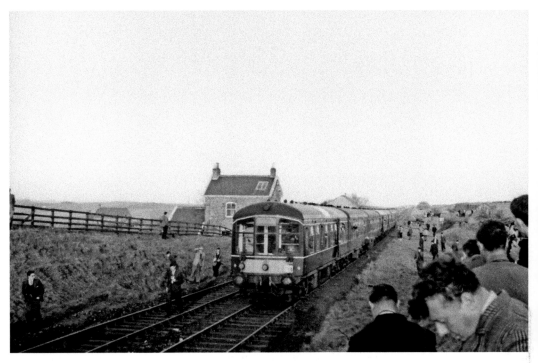

Excursion train for the Railway Correspondence & Travel Society's North Eastern Area No. 2 Railtour at Waskerley using a 'Derby Lightweight' Diesel Multiple Unit on 10 April 1965. (Phil Bailey)

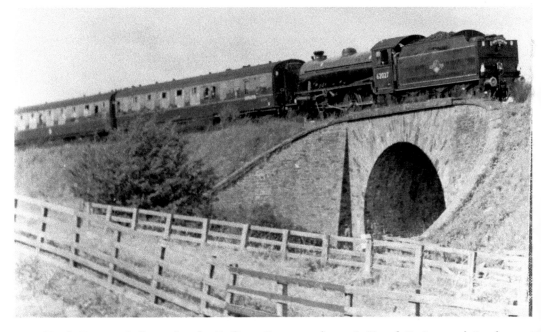

North Eastern Railtour for the Railway Correspondence & Travel Society and Stephenson Locomotive Society hauled by K1 Class 62027, seen crossing the road at Whitehall on the Burnhill deviation, heading down towards Rowley. This is believed to be the last steam passenger train on the line, on 28 September 1963. (Beamish Museum)

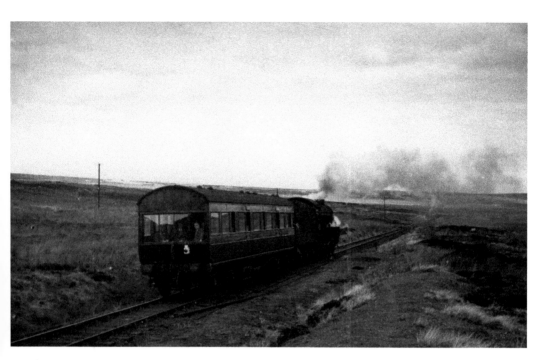

K1 class 2-6-0 locomotive near Parkhead station with an inspection saloon. (Ken Hoole Collection – Head of Steam – Darlington Railway Museum)

March – the month and a half delay was owing to snow meaning British Railways wagons at Burnhill couldn't be brought back![121, 122]

The decaying ruins of the engine houses and other remnants of the closed line attracted enthusiasts in the years leading up to closure, with special trains carrying them over parts of the line which had not seen passengers for many years. One of the most apt and atmospheric descriptions of the line follows a visit from one of the finest industrial and transport writers, L. T. C. 'Tom' Rolt, who wrote about the Crawley and Weatherhill inclines after their closure, describing them as 'reminiscent of certain inland parts of Cornwall. Here, above the 1,000-foot contour, is a vast expanse of open moorland made lonelier and more desolate by the evidence of bygone activity: ruined engine-houses and chimney stacks; the road bed of a long forsaken railway climbing steeply beside the road. These traces of lost endeavour, given over now to the sheep and the buzzards are all that remain of the westernmost extension of what was once described as "one of the most wonderful railway rarities in existence – the Stanhope & Tyne."'[123]

Rolt was fortunate enough to see the original engine houses at Crawley and Weatherhill before they were demolished in the 1960s, although the 1919 engine house at Weatherhill

121 Whittle, G., *The Railways of Consett and North-West Durham* (Newton Abbot: David & Charles, 1971) p. 216
122 Whittle, G., *The Railways of Consett and North-West Durham* (Newton Abbot: David & Charles, 1971) p. 208
123 Rolt, L. T. C., *George and Robert Stephenson: The Railway Revolution* (London: Longmans, 1960) p. 262

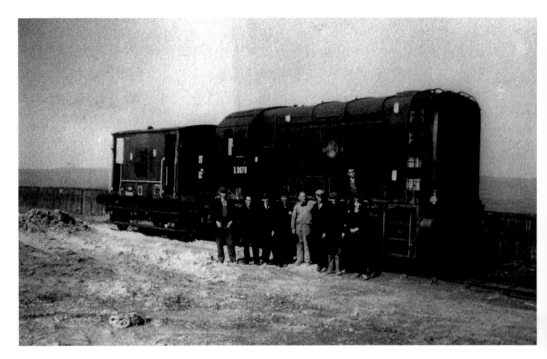

English Electric 350 hp Class 08 shunting locomotive D3879 of British Railways at the head of Weatherhill Incline, said to be the last train on the Waskerley branch. (Kind courtesy of Matthew Oliphant, not to be reused)

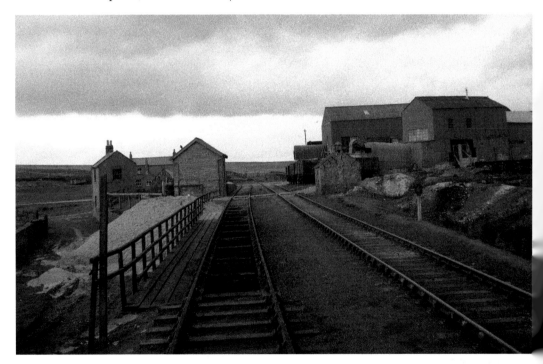

Parkhead station in its final years showing the coal depot on the left and buildings for the nearby quarry. (J. W. Armstrong Trust)

lasted until the early twenty-first century. After the closure of the line in 1951, the adjacent quarry used the engine house for its pan mills – it stood until 2003 when it became unsafe and followed the same fate as its predecessors. Consett steelworks was closed in 1980, followed by the Pontop & South Shields branch. Much of the route of the Stanhope & Tyne, following its later locomotive worked route, which included stretches of the original line, has become an integral part of Sustrans c2c cyclepath. On the Wear & Derwent route, through Consett the cyclepath follows the original line as closely as possible (a bypass road covers much of it) then continues on the trackbed over Hownes Gill viaduct and through the site of Rowley station, then from Whitehall follows the 1859 Waskerley deviation to Burnhill junction before returning up the Weardale Extension Railway to Waskerley, taking the 1847 deviation then splitting off at Parkhead to follow the Weatherhill & Rookhope line. Although the trains are long gone, the remarkably intact nature of its route together with the written and photographic record mean it is unlikely the memory of the Wear & Derwent Railway will be forgotten.

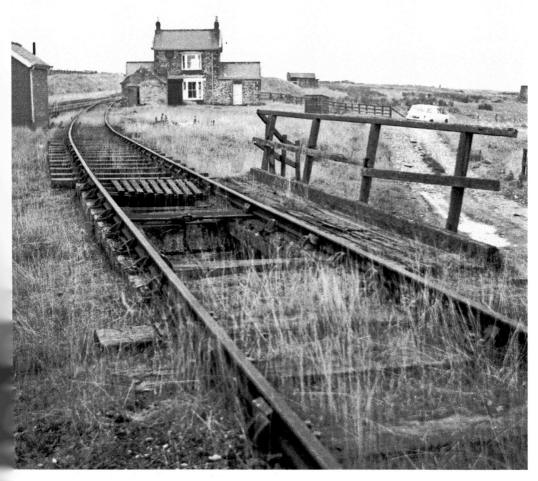

Coal depot at Waskerley with the station building in the background. (Beamish Museum)

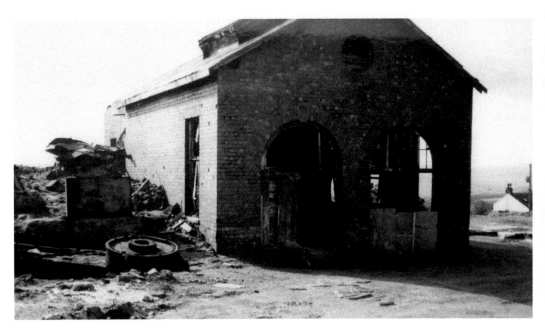

Remains of the 1919 Weatherhill engine house. (Kind courtesy of David Young, not to be reused)

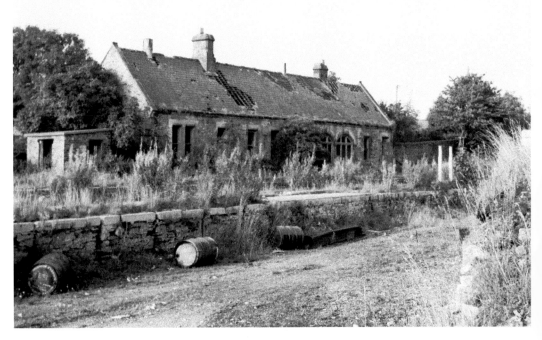

Rowley station nearly a century after being built, seen in a derelict state before being rescued by Frank Atkinson and taken down stone by stone for relocation to his planned open-air museum. (Beamish Museum)

Rowley revived! Relocated to Beamish Museum in the 1970s and formally opened – the first relocated building of many to the museum – in 1976 by Poet Laureate John Betjeman, Rowley station is now thriving. Seen here with a justifiably proud Frank Atkinson, the man who created Beamish, with his staff. (Beamish Museum)

Acknowledgements

Following the publication of *The Stanhope & Tyne Railroad Company* the response from those who live in the area or have an interest in the railway has been wonderful. Thanks as always go to those who supported me in the creation of that work and this unintended sequel (which itself will hopefully spawn another sequel covering the eastern half of the Stanhope & Tyne in later years). Cocoa, my faithful companion who passed away as this work was underway and was helpful as both a comfort and distraction when needed, is rightfully due thanks. Early railways expert Anthony Dawson has, as always, been of

Looking towards Weatherhill incline, Parkhead station is now a tearoom.

assistance, and Julian Harrop at Beamish Museum on hand for use of their collections. Staff at Head of Steam, Darlington Railway Museum, have been very helpful in using the Ken Hoole Collection and in accessing 'Derwent', and my fellow members of the North Eastern Railway Association have also been of great use, particularly Ernest Bate, who is working on a highly detailed book on the railways of Weardale which I await with keen anticipation. Chris Freeman, Matthew Oliphant and Vanessa Skarpari have supplied wonderful information and photographs from their relatives who worked on the line, which have been great additions to this book. Previous writers and researchers of the railway Frank Atkinson, L. T. C. 'Tom' Rolt, T. E. Rounthwaite, W. W. Tomlinson and George Whittle all deserve mention for inspiring the book and providing a base level for my further research into the line. Finally, I am highly grateful to Amberley Publishing for allowing this sequel to exist.

Bibliography

Archival

Beamish Museum
Photographic Archive

Durham County Records Office
Records of Stockton & Darlington Railway
CP/Shl Records of Shildon locomotive works
D/Ki Records of Kitching Foundry
D/XD Records of Stockton & Darlington Railway

Head of Steam, Darlington Railway Museum Ken Hoole Study Centre
Ken Hoole Photographs & Documents collection
RH Inness notebooks

The National Archives
AN 13 British Transport Commission
RAIL 390 London & North Eastern Railway
RAIL 663 Stanhope & Tyne Rail-Road Company
RAIL 667 Stockton & Darlington Railway
RAIL 716 Wear & Derwent Junction Railway
RAIL 1021 TE Harrison

Published

Addyman, J. F., *North Eastern Railway Engine Sheds* (Cramlington: North Eastern Railway Association, 2020)
Atkinson, F., *Industrial Archaeology of North-East England Volume 1* (Newton Abbot: David & Charles, 1974)

Atkinson, F., *Industrial Archaeology of North-East England Volume 2: The Sites* (Newton Abbot: David & Charles, 1974)

Baldwin, J. H., 'The Stanhope and Tyne Railway; a study in business failure' in *Early Railways: A selection of papers from the First International Railway Conference*, edited by Andy Guy and Jim Rees (London: Newcomen Society, 2001) pp. 325–341

Holmes, Dr P. J., *Stockton and Darlington Railway 1825–1975* (Ayr: First Avenue, 1975)

Hoole, K., *A Regional History of the Railways of Great Britain Volume 4: The North East* (Newton Abbot: David & Charles, 1965 (1978))

Hoole, K., *North Eastern Locomotive Sheds* (Newton Abbot: David & Charles, 1972)

Mountford, C.E., *Rope & Chain Haulage: The Forgotten Element of Railway History* (Melton Mowbray: The Industrial Railway Society, 2013)

Mountford, C. E., and Holroyde, D., *Industrial Railways and Locomotives of County Durham Part 1* (Melton Mowbray: Industrial Railway Society, 2006)

Pearce, T. R., *The Locomotives of the Stockton and Darlington Railway* (London: Historical Model Railway Society, 1996)

Proud, J. H., *The Chronicle of the Stockton & Darlington Railway to 1863* (North Eastern Railway Association, 2008)

Rolt, L. T. C., *George and Robert Stephenson: The Railway Revolution* (London: Longmans, 1960)

Rounthwaite, T. E., *The Railways of Weardale* (Railway Correspondence and Travel Society, 1965)

Tomlinson, W. W., *The North Eastern Railway, its Rise and Development* (Newcastle: Andrew Reid, 1914)

Warren, K., *Consett Iron 1840 to 1980, A Study in Industrial Location* (Oxford: Clarendon Press, 1990)

Whishaw, F., *Railways of Great Britain and Ireland Practically Described and Illustrated* (London: John Weale, 1842)

Whittle, G., *The Railways of Consett and North-West Durham* (Newton Abbot: David & Charles, 1971)

Williamson, C. and D., *Railway Snowploughs in the North East* (North Eastern Railway Association, 2014)